WRITING AND ILLUSTRATING THE
GRAPHIC
NOVEL

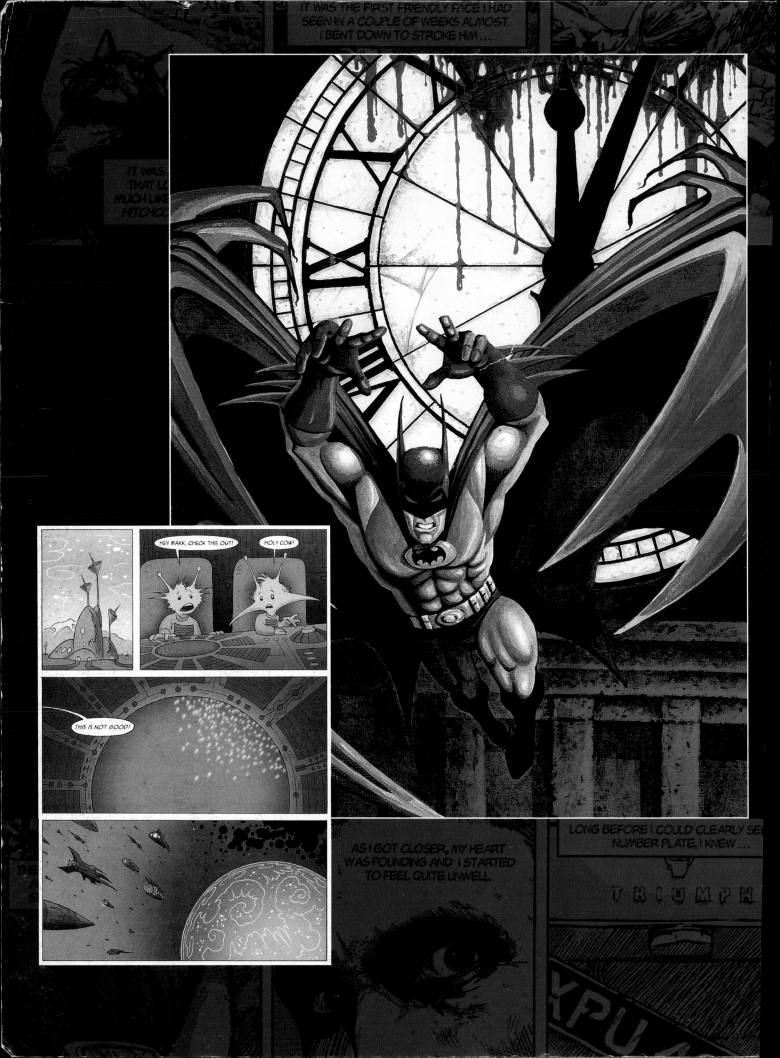

WRITING AND ILLUSTRATING THE
GRAPHIC
NOVEL

EVERYTHING YOU NEED TO KNOW TO CREATE GREAT GRAPHIC WORKS

MIKE CHINN

BARRON'S

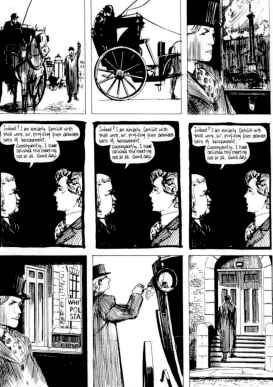

First edition for the United States, its territories and dependencies, and Canada published in 2004 by Barron's Educational Series, Inc.

A QUARTO BOOK

All inquiries should be addressed to:
Barron's Educational Series, Inc.
250 Wireless Boulevard
Hauppauge, New York 11788
www.barronseduc.com

International Standard Book No. 0-7641-2788-8

Library of Congress Catalog Card No. 2003110234

Conceived, designed, and produced by
Quarto Publishing plc
The Old Brewery
6 Blundell Street
London N7 9BH

QUAR.IGN

Senior project editor Nadia Naqib
Art editor Anna Knight
Designer Paul Griffin
Assistant art director Penny Cobb
Text editor Julie Pickard
Editorial assistants Jocelyn Guttery, Kate Martin
Picture research Claudia Tate
Photographer Paul Forrester

Art director Moira Clinch
Publisher Piers Spence

Manufactured by Universal Graphics Pte Ltd, Singapore

Printed by Star Standard Industries Pte Ltd, Singapore

9 8 7 6 5 4 3 2 1

CONTENTS

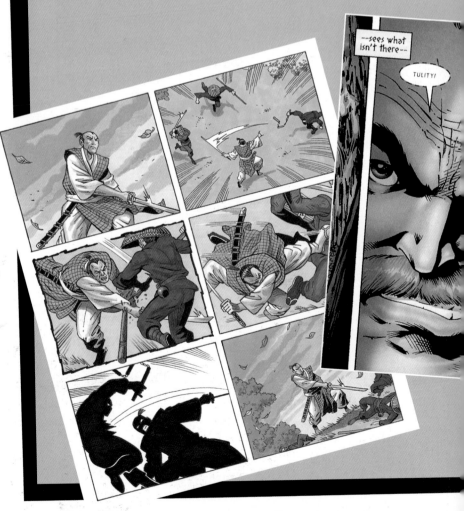

WHAT IS A GRAPHIC NOVEL?

So what exactly is a graphic novel? Even more difficult, what is understood by the term? What do people think of when you mention "graphic novel"? An overpriced comic book, or a kid's comic with delusions of grandeur?

CHARLES DICKENS
His fiction was originally published in serial form, before being collected into novels we know today.

To start with definitions, a novel is usually described as something like "a lengthy fictional prose narrative, normally dealing with human relationships, the plot unfolding through the actions, speech, and thoughts of the characters". And graphic means pictures. A graphic novel is therefore a long work of fiction in pictures, which makes a comic book the equivalent of a short story, or an episode in a longer story, right?

These, unfortunately, are false analogies. Novels deal with people—lots of characters, all interacting in some way and driving the story forward, so that by the end there will have been major changes in the main characters, as well as the status quo. The short story, meanwhile, is usually about an idea—the effect on a small group of characters, or sometimes just a mood piece. Many monthly comic books, to use an analogy that will occur frequently in this book, are more like episodes of a TV series, back in the days when each episode closed with order restored. No matter how crazy it became during an episode, by the end it was as if nothing had occurred. (This was simply so that a TV

series could be shown in any order when it went to syndication). A graphic novel, however, is a full, feature-length movie.

WHERE DID IT ALL START?
Most people in the field consider the birth of graphic novels to have occurred in 1978 with Will Eisner's *A Contract with God*. Eisner actually coined the phrase "graphic novel" while the book itself dealt with "real" people—not weirdoes in funny costumes. It was concerned with the heartbreak and hope of real life, and loudly proclaimed that the comic book format could deal

BOOKS IN COMIC FORMAT
A selection of comic books from the 1950's and 60's, adapted and simplified classic stori[...]

with any subject—and do it in a sensitive, adult manner. The book was also printed on quality paper and bound with heavy card covers. Everything from the quality of the writing and artwork to the production values said this was something special. Since then, Eisner's regular output has certainly fit this definition: long, complex, character-led stories (often with strong autobiographical elements) that are beyond the normal comic book. His most recent book, *Fagin the Jew*, is a prequel, of sorts, to Dickens' *Oliver Twist*.

Not all critics, however, agree that graphic novels are a mere 25 years old. Back in the 1930s, Lynd Ward produced novels told entirely as woodcut images (*God's Man*, *Madman's Drum*), with no narrative or dialogue text. In 1967, artist Gil Kane (*Green Lantern*, *The Atom*) experimented with a violent, noir-like black and white book, *His Name is Savage*. It received a mixed response: the critics were horrified, but the readers loved it— probably because they were the same ones who had grown used to such underground comics as *The Fabulous Furry Freak Brothers*, *Fritz the Cat*, and *Mr. Natural*.

The old Classics Illustrated series of comic books of the 1950's and 60's were literally books in comic format. Dickens, Jules Verne, H. G. Wells and many more were

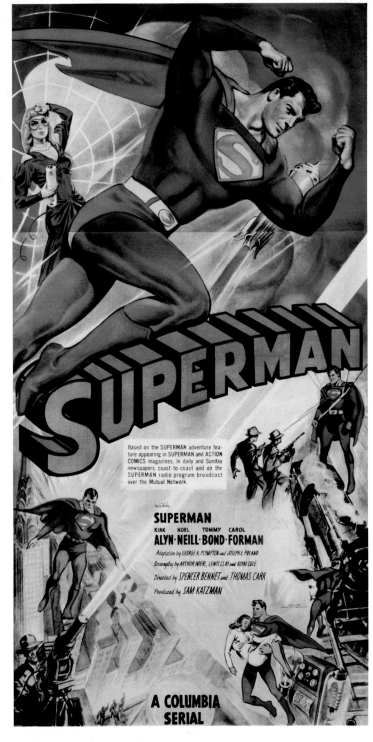

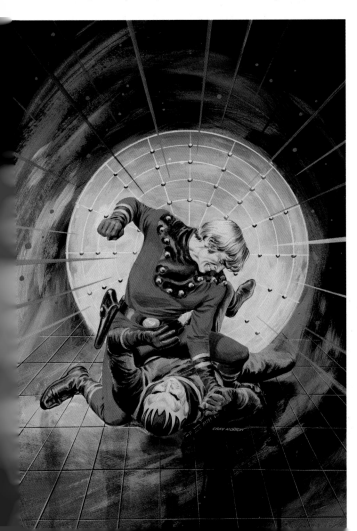

THE CLASSICS
Many classic novels have made it into graphic format, along with characters from myth and legend, and figures of popular culture such as Superman (above) and Flash Gordon (left).

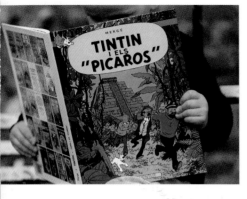

EUROPEAN GENIUS

Created by Hergé (real name George Rémi), Tintin is recognized worldwide. One of the most popular characters from graphic novels, he's probably the most long running.

the most familiar comic characters on the planet. His books sell in all corners of the world and in countless translations. The same is true of Asterix the Gaul, created by Goscinny and Uderzo. Somehow, the anarchic humor (and terrible puns) manages to rise above translation. The French artist Phillipe Druillet was also creating his own unique brand of decadent science fiction and fantasy books. The coffee table sized books *Lone Sloane/Delirius* and *Yragael/Urm* were originally published from 1972-75 (English translations published by Paper Tiger).

adapted—and often grossly oversimplified—for the books. Because each title was rarely much longer than the average comic book, often badly drawn and cheaply produced, they can probably be relegated to the "close, but no cigar" tray.

MEANWHILE IN EUROPE

In Britain, during the post-World War II era, the Scottish newspaper and magazine company, D. C. Thomson, used to publish several titles of "picture digests"—small, pulp-sized comics with 70-odd pages of black and white artwork, which, although almost all have since disappeared, were probably the last examples of a uniquely British phenomena. In mainland Europe, the tradition for large-format comic books is well established and dates back decades. Hergé's Tintin is probably one of

THE MANGA STORY

Japan, of course, has long had a near obsessive love affair with comics. The word "Manga" is now as familiar in the West as the East, with the form's unique stylization instantly recognizable. In Japan, Manga covers a bewildering range of subjects and genres, but over here the science fiction dystopias typified in Katsuhiro Otomo's *Akira* and Yukito Kishiro's *Battle Angel Alita* are the most familiar. Though it is probably through the animated movies (and various TV incarnations like *Gundam Wing*) that the West knows Japanese comics, there are more comics and graphic novels sold in Japan than the rest of the world combined.

ADAPTATIONS

Early on, it was clear that graphic novels would be an ideal vehicle for adaptations of existing conventional novels and stories. Byron Preiss published books in a variety of formats and genres, ranging from *The Illustrated Harlan Ellison* and *The Illustrated Roger Zelazny* to the Howard Chaykin-illustrated adaptation of Alfred Bester's *The Stars my Destination*.

But it wasn't just adaptations. Established authors were also drawn to the new medium. Science fiction author Samuel R. Delany wrote, with Howard Chaykin drawing, *Empire* for Byron Preiss (1978), a stunning space opera that eschewed normal speech bubbles and text panels and instead concentrated on the artwork and arranged text and speech outside the panels. The

ALIEN WORLDS

Part of the first *Alien* movie's impact was down to the nightmarish landscape dreamed up by Dutch graphic artist, H. R. Geiger, who also designed the creature.

Psychiatry knows that the joys and terrors of private phantasies are a common heritage shared by all mankind. Guilts and terrors could be interchanged, from one man to the next. The therapy department at Combined Hospital had recorded thousands of emotional tapes and boiled them down to one all-inclusive all-terrifying performance in Nightmare Theater.

Foyle awoke, panting and sweating, and never knew that he had awakened. He was pursued, entrapped. He screamed. He ran. Through the cacophony of grinding, shrieking, moaning, pursuing that assailed his ears, muttered the thread of a persistent voice.

"Where is 'Nomad' where is 'Nomad' where is 'Nomad' where is 'Nomad'?"

"'Vorga,'" Foyle croaked. "'Vorga.'"

He had been inoculated by his own fixation. His own nightmare had rendered him immune.

"Where is 'Nomad' where have you left 'Nomad'? what happened to 'Nomad'? where is 'Nomad'?"

"'Vorga,'" Foyle shouted. "'Vorga.' 'Vorga.' 'Vorga.'"

In the control booth, Dagenham swore. The head of psychiatry, monitoring the projectors, glanced at the clock. "One minute and forty-five seconds, Saul. He can't stand much more."

"He's got to break. Give him the final effect."

They buried Foyle alive, slowly, inexorably, hideously. He was carried down into black depths and enclosed in stinking slime that cut off light and air. He slowly suffocated while a distant voice boomed. "WHERE IS 'NOMAD'? WHERE HAVE YOU LEFT 'NOMAD'? WHERE YOU CAN ESCAPE? IF YOU FIND 'NOMAD.' WHERE IS 'NOMAD'?"

... But Foyle was back aboard "Nomad" in his lightless, airless coffin, floating comfortably between deck and roof. He curled into a tight foetal ball and prepared to sleep. He was content. He would escape. He would find "Vorga."

"Impervious bastard!" Dagenham swore. "Has anyone ever resisted Nightmare Theater before, Fritz?"

"Not many. You're right. That's an uncommon man, Saul."

"He's got to be ripped open. All right, to hell with any more of this. We'll try The Megal Mood next. Are the actors ready?"

"All ready."

▲ THE STARS MY DESTINATION

Alfred Bester's classic science fiction novel rendered in graphic format by Howard Chaykin.

following year *The Swords of Heaven, the Flowers of Hell* was produced, a new adventure of Michael Moorcock's Eternal Champion character, plotted by Moorcock and realized by Chaykin.

TURNING POINT

You'll notice that superhero titles have yet to be mentioned. At first, there seemed to be a deliberate attempt to keep graphic novels away from the established costumed heroes and character clichés. Following Eisner's lead, writers and artists wanted to go someplace different with graphic novels, even if it was just creating a novel told in pictures.

It would be impossible to overview graphic novels without mentioning two titles: *The Dark Knight Returns* and *The Watchmen*, both from D. C. Comics. They met an unprepared world in 1986 with impeccable timing. Frank Miller's reinvention of a darker, more vengeful Batman, and Alan Moore and Dave Gibbons' post-modern evaluation of a world where superheroes really exist, hit a nerve with the reading public. The impact of both titles can be felt to this day throughout comic book publishing. But more significantly, neither title was originally published as a graphic novel. Both were published as mini-series, only collected into graphic novel form after the initial series run had completed. In fact, they work perfectly as graphic novels, each episode flowing flawlessly with the others, acting like chapters of a larger work. This method has precedents in the field of conventional novels—Dickens' books were all originally published as magazine serials, and no one seriously

argues that the finished articles are anything but novels. That *The Dark Night Returns* and *The Watchmen* had the same artists throughout also created a sense of cohesion.

As a result, the majority of graphic novels published by the larger companies (D. C., Marvel, etc.) tend to be repackaged mini-series, or issues from a continuing title. Not exclusively, of course. D. C.'s *Elseworlds* series—where familiar characters are set in different, sometimes experimental, roles—is a perfect vehicle for a one-shot. Other examples would be Alan Davis' *The Nail* and *Gothman* by Gaslight. In fact, Batman seems to be a favorite for both *Elseworlds* stories and one-shot graphic novels that are set in the D. C. universe, but outside the regular monthly titles.

THE FUTURE OF THE GRAPHIC NOVEL

Whether the graphic novel was born in the 1930's or 1970's, in the U.S. or Europe, we've come to understand what most people expect when reading one. It is a lengthy work of fiction, told in pictures, that will stand on its own, needing no prequels or sequels to explain it. Generally, it will also be aimed at a more mature audience, and will have superior production values to regular monthly titles. By its very nature it can be experimental—taking the familiar and subverting it. It can be anything between 30 to well over 100 pages long. The subject matter will be as wide-ranging as that found in conventional novels—the only limits are the writer's and artist's imaginations, and the publisher's nerve. It can be written specifically as a whole, collected from a multi-part mini-series, or even an ongoing title.

Grown up comics? Perhaps. Taking the far-reaching, emotional world of conventional novels, the familiar visual techniques of comics and tossing in a few ideas from the movies, graphic novels have created their own space and become something unique. A new voice for the 21st century.

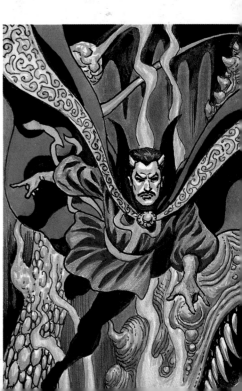

▶ FROM BEYOND

Not all characters inhabit the recognizable world. Originally drawn by Steve Ditko, here the mystical hero Dr. Strange is realized by Argentinean artist Quique Alcatena.

DEFINING THE GRAPHIC NOVEL

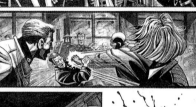

KEY FEATURES

The clue is in the name—the graphic novel is a full length story that is told in pictures. It is usually a complex tale that, by its resolution, will have brought about major changes in the central characters' way of life: lovers meet, are torn apart by circumstances beyond their control, then are finally reunited; the young hero is plucked from poverty to save the galaxy.

Graphic novels are often aimed at an older readership than the average comic book. That is not to say that you won't get superheroes turning up; Alan Moore's *Watchmen* and Frank Miller's *The Dark Knight Returns* are both firmly placed in the world of costumed superheroes. While a monthly comic book may be looked at as a single chapter in a continuing saga, the graphic novel is the whole story. A comic book is like an episode in a TV series, whereas the graphic novel is the full movie, complete with special effects and stereo sound.

VISUAL DEVICES (SEE P.26)

The positioning of characters in the frame can set the mood of the sequence. Here, the two characters' heads aren't moving from panel to panel, emphasizing a moment of stillness.

FRAME DEVICE (SEE P.26)

Framing is of the utmost importance in the graphic novel. In this panel, the Hansom cab's window acts as the framing device. The scene through the window in this panel has changed—see the top right of page—showing movement and passage of time.

LETTERING (SEE P.110)

Lettering is a vital part of the strip and needs to be clear and precise, but also lend itself to becoming part of the visual effect.

FRAME FORMAT (SEE P.22)

Frames can be drawn in several ways. Many publications prefer 5–7 frames per page, but it is still possible to have fun within this format by varying their dimensions.

VISUAL STYLE (SEE P.72)

Strips are drawn in a variety of different ways—colored from black-and-white inks, painted, or computer generated. This example was created using pen and ink.

CROPS (SEE P. 102)

Cropping is used to create drama. A close up of a face (as shown here) is a quick way to portray a character's innermost feelings.

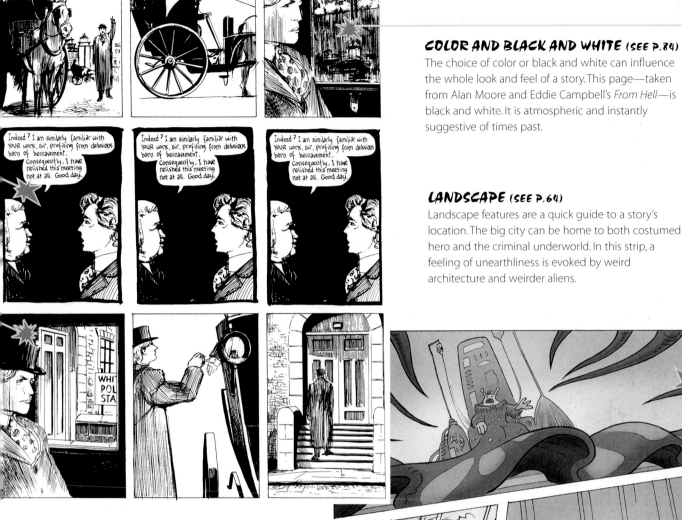

COLOR AND BLACK AND WHITE (SEE P.84)

The choice of color or black and white can influence the whole look and feel of a story. This page—taken from Alan Moore and Eddie Campbell's *From Hell*—is black and white. It is atmospheric and instantly suggestive of times past.

LANDSCAPE (SEE P.64)

Landscape features are a quick guide to a story's location. The big city can be home to both costumed hero and the criminal underworld. In this strip, a feeling of unearthliness is evoked by weird architecture and weirder aliens.

SOUND EFFECTS
(SEE P.112)

Everyone's favorite cliché, sound effects are still used, although more sparingly these days. This actually makes the few effects that are used more dramatic, but on the whole graphic novels let the action speak for itself.

SPEECH BUBBLES (SEE P.28)

Speech bubbles are the only clue a reader has to the tone and pitch of a character's voice. Is he or she angry? Calm? Maybe he or she is not even human—in which case this must be conveyed to the reader, usually with differently shaped balloons.

TYPE OF HERO (SEE P.62)

What sort of hero do you want? A superhero? An anti-hero? Someone with barely any redeeming qualities at all? Not all graphic novels aim for the traditional, clean-cut image. Even Lucifer is the hero of one title.

SUPERHERO

Ever since the Superman and Batman characters were launched in the 1930's, there has been a growing army of costumed crime-fighters battling increasingly bizarre villains. Taking their cue from the adventure pulps—with the familiar good guy/bad guy layout—these super-heroes came to dominate the newly emerging comic book format. The proud slogan became "All in Color for a Dime!"—since up to that time most newspaper strips had been printed in black and white.

STRANGE POWERS

The various capabilities of each character grew more and more fantastic. Batman, Nick Fury, and Captain America are human (even if Cap did get a boost from a secret U.S. Army serum in WWII…), but it wasn't long before both readers and publishers wanted something more dramatic. Some heroes gained their powers through scientific devices (Iron Man's suit, Green Lantern's ring), some through accidents (the Flash, Spider-Man, the Hulk), others were born with them (mutants like the X-Men), and then others attained "god" status (Thor, Orion). But all require suitable opponents. It is an unwritten rule that the villain cannot be more clever or stronger than the hero (or else how is good supposed to triumph?). The Joker may be a disfigured psychotic, but he is recognizably human—as are most of Batman's foes. Orion, of the late Jack Kirby's *New Gods*, faces his greatest foe in *Darkseid*—The Devil by any other name and, in a neat plot twist, Orion's own father.

READ THESE!

To get an insight into this genre, read:

▶▶ *Top 10 (America's Best Comics). Alan Moore writes a police procedural—in a city where the entire population has superpowers, alter egos, and costumes. Just what does constitute normal when everyone is extraordinary?*

▶▶ *Superman and Batman: Generations (D. C.). An Elseworlds tale spread over several generations—from the 1930s to the far future. An excellent lesson from John Byrne in how to take the changing (and contradictory) histories of two of the most famous superheroes, and make a continuous narrative.*

▶▶ *The Dark Knight Strikes Back (D. C.). Frank Miller's sequel to The Dark Knight Returns adds more of the Silver Age heroes of D.C.'s past, recasting them in a modern shape. Another excellent example of reworking old themes.*

SECRET IDENTITIES

All superheroes have a secret identity. The usual reaso to protect their loved ones—but it's so often also a clic plot hook. How many times has Spider-Man almost b unmasked? Does anyone really believe Lois c recognize Clark Kent as Superman just because he taken off his glasses and let his hair flop over his forehe

These days, secrecy is much less important, characters often call each other by their "real" name secret identity is now just a given—like carrying a driv license.

▶ **A SENSE OF POWER**

Batman is an iconic image—here exuding a grim determination. The use of foreshortening enhances that feeling of power.

▲ **AND SUPER SENSES**

Super powers are what define the superhero. Spider-Man has his spider-sense—an extra-sensory gift that tells him danger is at hand. Also his webbing gets around his inability to fly.

Gothic Horror and Fantasy

Neil Gaiman's reinvention of D. C.'s old *Sandman* character as *Morpheus, Lord of the Dreaming*, is acclaimed beyond the graphic novel genre. James O'Barr's *The Crow* has inspired a movie and spin-off novel by Poppy Z. Brite, and goth comics have become a major sub-genre.

Horror has had a rough ride over the years. EC's *Tales from the Crypt* and *Vault of Horror* were judged too corrupting an influence on America's youth and were ultimately banned. Warren's *Eerie* and *Creepy* magazines maintained the tradition for a while, along with Skywald's less-successful *Psycho*, *Nightmare*, and *Scream*. A new generation of horror titles now has Hollywood taking notice. Steve Niles' *30 Days of Night* has interested Sam Raimi (director of *Spider-Man*), Marvel's *Blade* inspired two movies, and *Hellboy* made it to the screen in 2004.

Wendy and Richard Pini's *Elfquest* saga is the most popular fantasy title at present, with D. C. re-launching it. But fantasy comics are also responsible for important Manga titles such as *Nausicaa*. Some of the first modern fantasy comics to be popular were Marvel's *Conan* adaptations. Dark Horse has just launched its own *Conan* title, in addition to publishing that most enduring of fantasy heroes: *Tarzan*.

▶ **NOT MORE ALIENS...?**
Both horror and fantasy will call upon the fantastic eventually, and for such creatures the rules are... there are no rules. Wild animals such as wolves are scary, but take the werewolf, for example, something that's as much a man as it is a creature. With a human intellect but the savage instincts of a deadly carnivore, it becomes really scary.

▶ **LANDSCAPES OF THE MIND**
The major component of all horror—regardless of style—is mood. Contemporary horror will have an overall sense of dread; gothic comics are both fatalistic and hilarious. Dark humor is a major characteristic of the best Indy Goth comics. This example bears all the hallmarks of the genre—decaying atmosphere, fatalism—and a weird sense of humor.

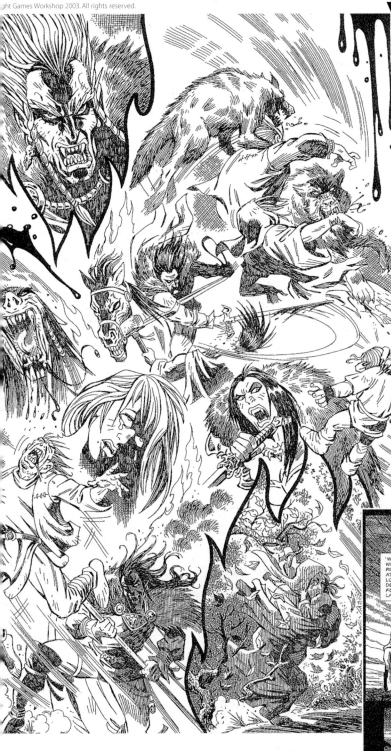

READ THESE!

To get an insight into these genres, read:

▶▶ *THE CROW (TITUS BOOKS) JAMES O'BARR'S classic—about as Goth as you can get. For anyone who's only seen the movie, this is the real deal.*

▶▶ *SANDMAN (D. C./VERTIGO) NEIL GAIMAN. Another milestone. Gaiman recreated a Golden Age character as a creature of night and dream and influenced a generation. Still going strong with various spin-offs.*

▶▶ *HELLBLAZER (D.C./VERTIGO). Various artists and writers have contributed to this series over the years, but it was Alan Moore who originally developed bloody-minded Brit, John Constantine, in D. C.'s Swamp Thing title. Hard-hitting and relentless dark fantasy.*

▶▶ *YRAGAEL/URM (PAPER TIGER). French artist Phillipe Druillet's bizarre and demonic fantasies have long delighted Europe. The English translation might not help the story flow—but with this kind of artwork, it hardly matters.*

▶▶ *ELRIC—THE DREAMING CITY (MARVEL). P. CRAIG RUSSELL. One of several adaptations of Michael Moorcock's most popular creation. Russell's artwork manages to combine elements of photo-realism and surrealism at the same time.*

▶ TO GORE OR NOT TO GORE...

Modern horror is pretty visceral, and *Hellblazer* and *Preacher* aren't kidding when they put "suggested for mature readers" on the cover. But you can often creep people out more with what you don't show, even in a predominately visual medium like the graphic novel. Here the terror to come is hinted at in the last frame.

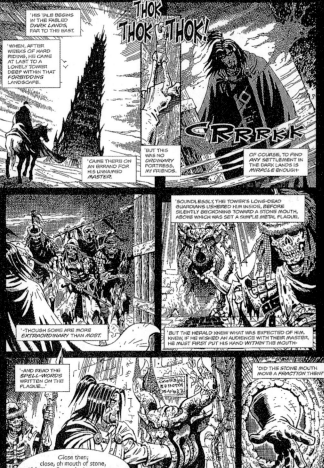

CRIME AND ACTION

One area where graphic novel writers are more than happy to go, while mainstream comic books seem to be no longer interested, is crime. The readership is generally considered to be older, and hard-hitting titles like *100 Bullets*, *Sin City: That Yellow Bastard,* and *Human Target* are the graphic equivalent of a Len Deighton or Eric Van Lustbader novel. Sex, violence, and strong language are part of the scene, along with a skewed (and often suspect) morality.

Action–adventure strips have been with us longer than science fiction. Popeye is a prime example—even though it is primarily comedy—its mixture of bizarre lands and weird cast still influences modern cartoons. Newspaper strip adaptations such as Peter O'Donnell's *Modesty Blaise* and *James Bond* thrived when spies were popular, and are direct ancestors of today's action comic. Both have been re-packaged and published by Titan.

▲ IT COULD JUST BLOW YOUR HEAD CLEAN OFF...

The use of firearms is routine in modern crime and adventure. And the effects of Magnum bullet are well understood. He calm scene erupts into violence, and end shockingly with a brutal—and apparen meaningless—gunshot to the head.

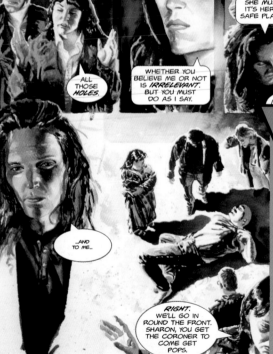

▶ LOVE AND DEATH

Sex and desire have always played just as big a part in crime as hatred, jealousy, or greed. Love and hate are often portrayed as two sides of the same coin. This scene shows the aftermath of a girl having killed a member of her own family—to whom she will eventually return.

READ THESE!

To get an insight into this genre, read:

▶▶ *100 BULLETS (D. C./VERTIGO).* An ex-government m hands out a gun with 100 untraceable bullets to vic who need to fight back.

▶▶ *SIN CITY: THAT YELLOW BASTARD (DARK HORSE). FRA MILLER.* Stark black and white artwork with a storyl that's anything but.

▶▶ *NIGHTMARE ALLEY (FANTAGRAPHICS).* Adapted by Underground artist Manuel "Spain" Rodriguez from William Lindsay Gresham's novel. A gritty look at the dodgers and grifters in a mid-20th century carnival.

▶▶ *TRANSMETROPOLITAN (D. C./VERTIGO). DARICK ROBER AND WARREN ELLIS.* Set in a dysfunctional future, thi anarchic series is similar to traditional crime noir th

▶▶ *STRAY BULLETS (EL CAPITAN BOOKS). Dave Lapham's* has been described as even more black and brutal t Frank Miller's *Sin City* books.

LITERARY GRAPHIC NOVELS

Graphic novels are a breeding ground for experimentation—both in artwork and writing. Any story can be prepared as a graphic novel—the Trojan Wars, even the Bible have been adapted into graphic novel format. Publishers of non-graphic books often shy away from stories they cannot instantly categorize; and cross-genre stories are definitely unwanted. The graphic novel field isn't so rigid—not with the smaller publishers who are more willing to take a chance.

What is Art Spiegelman's *Maus* if not literary? Patrick Atangan's *The Yellow Jar* is the first in a series of Japanese ukiyo-e period woodblock-style comics. And despite *Dr. Jekyll & Mr. Hyde*'s horror credentials, the book has become so much a part of the establishment that a graphic novel adaptation (from Lorenzo Mattotti and Jerry Kramsky) would probably qualify as literary as well.

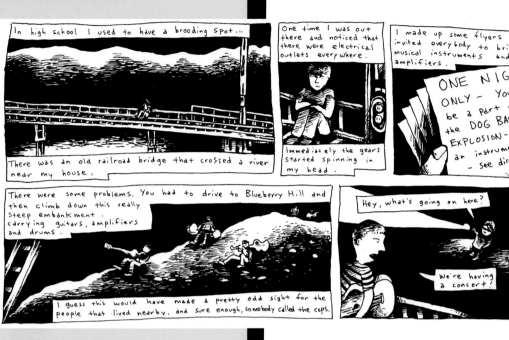

▲ **A SLICE OF LIFE**

These images, despite their cartoonish appearance, are true stories. But the stories they tell are so strange that a more realistic style would probably ruin their effect.

AUTOBIOGRAPHY

Autobiography forms a significant part of literary graphic novels. From the fictionalized autobiographies used in much of Will Eisner's work, and Art Spiegelman's *Maus*, to such personal works as Marjane Satrapi's *Persepolis*, and *Our Cancer Year* (Four Walls Eight Windows), where husband and wife team Harvey Pekar and Joyce Brabner describe a family in crisis. Rather than autobiography, *Safe Area Goradze* by Joe Sacco (Fantagraphics) is an example of New Journalism—where writers (led by the like of Tom Wolfe and Norman Mailer) use the forms and tropes of fiction to relate non-fiction. In this case it's the true story of the Bosnian city of Goradze during the Balkan civil wars of the 1990s.

Can anyone doubt the legitimacy of an art form that can deal sensitively and passionately with such subjects?

READ THESE!

To get an insight into these genres, read:

▶▶ *A Contract With God* (D. C.), Will Eisner. What many consider the first graphic novel—though it's actually several dissociated short stories. Strongly autobiographical, as many of Eisner's books have been since.

▶▶ *Maus* (Pantheon), Art Spiegelman retells the Holocaust using mice as the central protagonists—but never trivializes the horror. Again, strongly autobiographical and very moving.

▶▶ *Stuck Rubber Baby* (D. C.), Howard Cruse. Set during the 1960s in the South, this tackles the Civil Rights movement, gays, blacks, and Southerners head on without flinching.

▶▶ *Persepolis* (Pantheon), Marjane Satrapi. Quite topical—told as a memoir by a woman who grew up during the Iranian revolution.

▶▶ *The Golem's Mighty Swing* (Drawn & Quarterly), James Sturm. Using a 1920s Jewish baseball team as a metaphor for America, Sturm mixes Jewish and baseball mythologies, in black and gray on off-white paper that hint at how memory discolors everything.

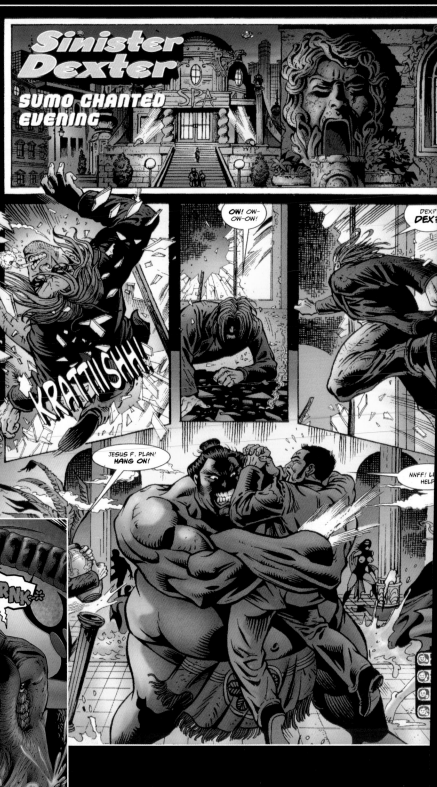

CHAPTER 2

ELEMENTS OF THE NOVEL

Graphic novels and comics are presented within a framework that portrays a story. All the shortcuts and devices used are familiar to everyone, though not everyone knows what they're called or how they're used in the storytelling process. This is okay if you're a reader, but if you want to script graphic novels, then at some point you're going to need to know what is

PANELS

A panel is a box containing a single picture—a moment in time, if you will. The picture is usually referred to as a shot. And just like a shot in a movie, it can be in close-up, long shot, middle distance, or extreme close-up.

Panels normally fit on the page in a simple grid pattern—five to seven panels per comic page are the norm (except for the splash page—see below). But it is not uncommon for artists to float some panels across others—again for aesthetic reasons, or as a dramatic device to highlight the contents of that panel (especially if the contents are also in extreme close-up—like a pair of menacing eyes).

Splash pages and full-page shots are often confused with one another. The splash page is normally the opening page (although it is becoming increasingly common to put it two to three pages into the story). It will contain the logo (if there is one), main title, and subtitle where necessary. It also has artist and writer credits, and all other such information. A full-page shot is just one huge panel, covering a single comic page. They can be very effective—especially if you're conveying a large, chaotic scene with many figures—but it shouldn't be used too often.

▶▶ SEE ALSO
All about layout, p.94

CHRONOLOGY

A story's chronology is dictated by the panel sequence. It is fine to jump back and forth between different scenes. Over-ambitious (and inexperienced) artists, experimenting with a page's layout can mislead the eye—dragging it in quite the wrong direction. There's nothing wrong with unconventional layouts—but remember, you're telling a story, and if your storytelling becomes confused you may lose your audience.

▼ REGULAR PANELS

This layout is as basic as you can get—with six panels laid out symmetrically.

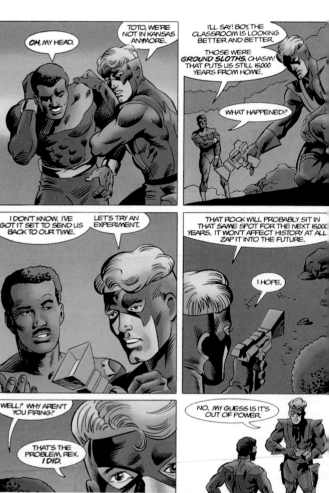

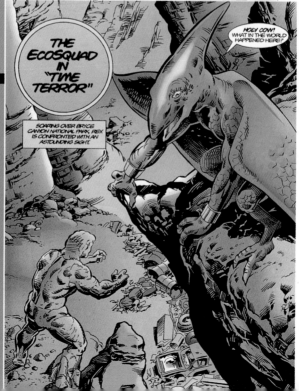

◀ SPLASH PAGE

The opening page of the book, normally incorporating the title, logo, and credits.

◀ FULL PAGE

Used when the artist wants to show a large scene, or show details that would crowd a smaller panel. Literally, it is seeing the big picture. Here, by using the larger canvas of a whole page, a sense of pastoral calm is created—a feeling of stepping back and taking a breath before the action really gets going.

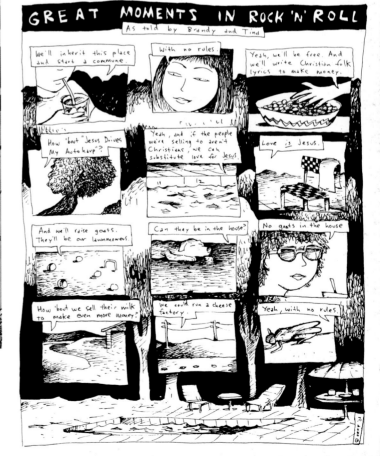

▶ FLOATING PANELS

Floating smaller panels over a larger full page gives a feeling of intimacy. The garden background here is the outside world, against which the characters' lives play out in the smaller pictures.

PUTTING IT TOGETHER

Below, some examples of how panels can be laid out for effect, and/or to progress the story without a word being said (or written).

◀ ZOOMING IN

Here are three panels, laid out horizontally. As the focus shifts—from a distant group seen against the landscape, to a close-up of the same group in the foreground—the panels get smaller. This not only narrows the reader's focus, it also exaggerates the closeness of the group—like cropping a picture.

▶ DEPTH AND SIZE

Here the panels are laid out vertically to show the height of a room, as well as to create the feeling of distance—as though looking in from a great height.

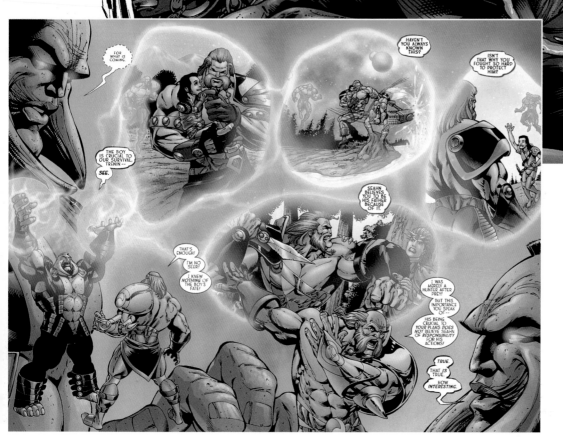

OVERLAPPING PANELS
A mostly conventional layout, but starting with overlapping panels, the events are almost simultaneous in story time.

TWO-PAGE SPREAD
A two-page spread shows how a lot of information can be covered using this device, or how it can be used simply for effect.

FRAMING DEVICES

Framing devices can be used within a panel—a means of focusing the reader's eye. Often, in a panel that contains several characters, you might want to ensure that the reader concentrates more on one panel than the others. This can be done in several ways: by having the character in closer shot than the others, by having the others spread evenly on either side (like a small audience) providing a focus point, or by having sections of the scenery effectively enclosing them—quite literally "framing" them within the panel. These are all different kinds of framing devices.

That's not to say you can't use the panel as the framing device. A popular sight gag among artists is using a character's head as a full-page panel. If the head is also against a background, then all the action taking place within the head frame has an internalized feel—like a flashback, or an introspection of some kind.

Another type of framing device can be an apparently disconnected scene that appears before and after the main story—perhaps an epilogue of some kind. This was (and still is) used in horror stories where they are "introduced" by whichever spooky character the book employs (Crypt-Keeper, Uncle Creepy, etc.).

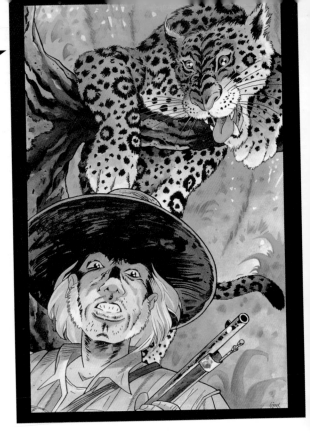

▲ LOOK UP
The first thing you see here is the man's face because of the dramatic shading. But a second glance reveals the big cat above him, effectively framed by the "real" frame's top and sides, as well as the man's hat.

► DRAWING THE EYE
Although the main character is in the foreground, the house in the background and the man's eye line draws the reader across the page, straight to the woman.

▲ FATAL ATTRACTION

The frames themselves are being used here to focus the reader's attention. The angled sides draw the eye to the central panel and the menacing figure that is actually bursting free.

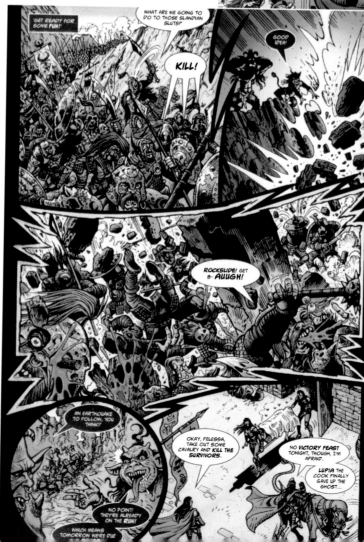

▲ ARCHITECTURE

Note how the central frames have been arched, giving the impression that the embattled sumo character is fighting in a ring.

◀ ASIDES

The bottom left panel acts like a spotlight—a small, neat circle among the ragged chaos around it—marking it out as something aside from the main action, but still important to the plot.

SPEECH AND CAPTIONS

Okay, you've got your story down visually, but what is everyone saying? This is where speech balloons come in—those odd little clouds floating all over the panel and obscuring the artist's work. There are several types of speech balloons. Straightforward speech balloons are ovals containing the dialogue (again, they're also referred to as word balloons—or simple balloons). The little squiggle that points to whoever is doing the talking is known as a pointer or tail. Thought balloons are really fluffy clouds with scalloped edges, and a stream of bubbles drifting out of the character's head (instead of a tail).

▼ A BURST

If you want to indicate volume, or that your character is stressed (or just that the words are coming out of a transmitter or phone) you use a burst—a balloon with jagged or spiky edges, and a pointer like a jag of lightning.

SHAPE OF BALLOONS

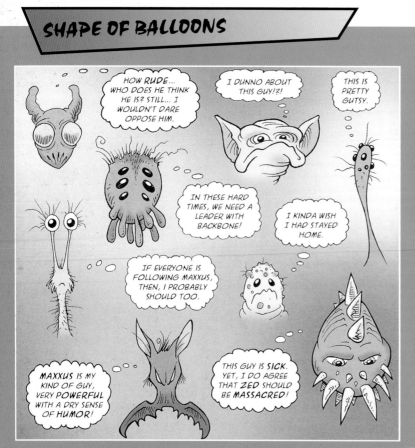

▼ STRAIGHTFORWARD SPEECH BALLOONS

These can come singular—or in multiples (depending on how wordy your characters are). The double balloon, shown here, is used to denote a new paragraph—or an aside.

▲ THOUGHT BALLOONS

The bubble used for thought balloons indicates the nebulous nature of thought.

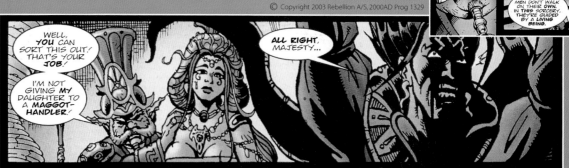

RRRAAAAAAAAAAA!!!!

◀ VOLUME

Here is an example of a volume balloon that is a step beyond the electric balloon. This time it is the lettering that matters—big, heavy lettering, often colored (red or orange is good) and in your face. The jagged edge leaves you in no doubt of the character's message.

▶ WHISPER BALLOONS

A soft or whispering voice is depicted by a whisper balloon; a normal speech balloon, but with the outline broken up into dashes. (You can also create the same effect by reducing the size of the lettering).

▼ CAPTIONS

Caption boxes contain the external narrative that fills in the detail of the story. They complement speech and artwork, and have gone beyond the "Meanwhile, in another part of the city…" cliché. They shouldn't waste time repeating what the artist has already drawn. Their purpose is to fill in the gaps we don't see. They can also be used to carry over speech from preceding panels or scenes—provided you put the text in quotation marks. Some comics even run the captions below the panels, containing narrative and quoted speech. Hal Foster's *Prince Valiant* strip was a prime example of this. Also, captions can run text you wouldn't normally see, such as on a computer screen.

CHANGING LETTERING

Use simple shorthand that everyone understands. **THIS IS A SHOUT** while THIS IS A WHISPER. Using italics *denotes words that are being spoken intensely.* Quite often a lettering artist will use **bold** to denote words that are being **stressed**, do you **see**?

Changing typeface completely can suggest Foreign or totally alien words "⋔ ⅄ ⌇ ♒⋔ ⌖ ◆⚳ ⋇ ⅄ ⌇ ⍀⋔ ⌘ ⅏ ⋌."

▶▶ SEE ALSO
Lettering, p.110

Clawed branches whipped past her and tore at her clothing as she ran past them, holding her arms in front of her to protect her face.

The boy's strange voice echoed in her head as she ran; "Never make deals with ogres..." Blinded by fear she never...
never...

CHARACTERIZATION

Characterization is one of the most important aspects of any story. You need to know who your people are, what motivates them, and then decide what their ultimate objectives will be. The plot is determined by your central character(s); he or she is the focus of the story.

A hero has to be heroic and must always put the well being of others before his/her own. But that doesn't mean he or she has to be a chrome-plated Boy (or Girl) Scout. Look at Spider-Man: he is both neurotic and insecure. And there is no reason your central character has to be heroic in the usual sense. In Bryan Talbot's *The Tale of One Bad Rat*, Helen is fleeing parental sexual abuse and eventually finds her peace in the landscape of the English Lake District. The only creature she can relate to is a rat. But as the lead character, it is her plight that concerns us.

►► SEE ALSO
Writing realistic characters, p.62

WHERE'S YOUR MOTIVE?

Everyone wants something. That is true of your hero, villain, and supporting cast. You, as the creator, have to provide that motive.

So what does your character want? To protect loved ones? Revenge? Or like Helen in *The Tale of One Bad Rat*, to simply escape the terror that is her daily life? In Brian K. Vaughan's *Runaways* (Marvel), a group of kids who have never met before join forces because they want to know why their parents change into strange costumes and sacrifice babies.

BEFORE JO-EY CAN FINISH HIS TALE, *GENERAL MAXUSS* AND HIS HENCHMEN, T BUTCHERING FOUR, BURST THROUGH THE WALL OF THE ROYAL CHAMBER...

OK ZED, TIME TO DIE!

▲ **REVENGE**
One of the primary character motivations—whether it is the hero who has been wronged, or the villain out for payback.

▶ BE AFRAID...

Everyone is scared of something, and it doesn't have to be the rats in Room 101. In fact, a fear of animals is something of a cliché. There is also fear of intimacy, fear of ridicule, fear of being found out you're not the big, tough guy everyone thinks you are, etc. In this example, the main character's fears are revealed during a nightmare.

▲ THE SPEAR CARRIERS

Our hero will have friends and colleagues, and by the nature of action, some of them are going to be involved in the plot. Consider why your hero hangs around with them in the first place. What is it he sees in them? In this graphic novel, subsidiary characters are introduced a montage of faces.

THE AGES OF MAN

Facial features change with age. Youth is unmarked by life. Maturity carves away youth's rounded features, and age dries up all confidence and nobility.

OBSERVATION FOR INSPIRATION

The most frequent question asked of any writer is: "Where do you get your ideas from?" Science fiction writer Roger Zelazny always replied: "Every night I leave out milk and cookies. In the morning they're gone—but there are loads of crazy ideas in their place!"

Zelazny's method notwithstanding, this chapter will show you where to find inspiration, how to encourage it, and what to do with it once you've found it.

OBSERVING AND RECORDING

There's no substitute for watching real people. Regardless of what kind of story you want to write—whether it's a superhero or social drama—you need to watch people. There's no way of getting around it—your book's going to have people in it. Ordinary people, extraordinary people—but people.

The Chinese say the longest journey starts with a single step. Even the strangest tale begins with people doing ordinary things—a young couple having a screaming match; a cop dealing with an aggressive drunk late at night; an old man at the supermarket checkout finding he doesn't have enough cash on him for the groceries. All mundane events, sure—but it's seeing how the people in each drama react that's important. The couple oblivious to anything except their anger, the cop calm and professional, the old guy flustered and embarrassed. You can put all them all together in the same supermarket at the same time, then spin out their imaginary lives from that moment in time, or rewind and show how they ended up in the same place.

▲ **NOTEBOOKS**

Write down anything that comes to you—in a notebook if you've got one, or on a scrap of paper if you don't. Stick notes with reminders all around your workspace.

▶ **ARTISTS' SCRAPBOOKS**

Artists should build up a reference library of images—their own scribbles, pictures, and photographs of things that might inspire them, and even magazine ads, which are good for faces and fashion.

RECORDING

If you're going to be pounding the streets looking at everything and everyone, awaiting that moment of inspiration, you'll need to record it somehow. Never rely on your memory—as Homer Simpson pointed out, every new thing you learn pushes some of the old stuff out.

Quickest and easiest is a notepad. Small enough to keep in your pocket, you can scribble down any stray thought that bubbles up during the day. And don't neglect to write it down there and then. It'll be gone like smoke otherwise. Take the time to write clearly, too. If you scribble too quickly you won't understand a word of what you wrote when you come to look at it a few days later. If you're lucky, there will be enough legible to jog your memory.

MINI-RECORDER

Mini-recorders are very useful—once you get the hang of using them. Because they're not much bigger than notepads, you can carry them anywhere. Of course, you have to get over the "Do I really sound like that?" phase, which is closely followed by the "What do I say?" phase. You have to learn to dictate—to take a moment to assemble your thoughts. Otherwise, there are going to be a lot of "Er…" and pauses with only the wind and background crowds to listen to. Don't try to reel off whole sentences—the odd phrase will do. You just need something to prompt you when you get back to the keyboard. It's like talking to an answering machine; everyone freezes the first time, but eventually you get used to it.

◀ ELECTRONIC MEMOS

Imagine how many ideas you can cram onto a 60-minute tape.

DIGITAL CAMERAS

Digital cameras and camcorders mean you can photograph anything instantly. Whether it's landscapes, cityscapes, or the frowning masses passing by on their way to work, you just point and shoot. If you don't get what you want the first time, delete, and try again.

The images you grab with a digital camera can be processed through Photoshop or a similar software package, and then be used as part of the artwork. Some wonderfully evocative comic art has been produced using a combination of camerawork and drawing.

Artists should always carry a sketchpad. A few simple sketches of interesting buildings or striking landscapes can be used later in your artwork. As with observing people, nothing beats taking down a bit of real life now and then. If you've got the nerve, sketch a few faces while you're at it, especially the more unusual ones. It will not only improve your technique, but it will help develop a repertoire of faces and expressions. There are far too many comic artists who seem capable of drawing only two or three faces and expressions. On the other hand, there are those—like Alex Ross and P. Craig Russell—who actually use live models for their work, which really makes a difference.

▶ LIFE SKETCHES
Use a sketchpad to capture everyday happenings.

FIGURE REFERENCE BOOKS

We've all seen artists' mannequins that help with the proportions and poses of figures. If you don't have one of these, a reference manual filled with photographs of people standing and acting in a variety of ways can be just as useful. These photographs are from different perspectives, and demonstrate how actions can look from various angles.

TYPES OF SKETCHPAD

Sketchpads come in a variety of sizes, both portrait and landscape, and have all types of paper surface. The trick is knowing which one to use and when to use it. Pocket-sized books are easy to carry, but are no good for large subjects—although if you're in a hurry, one with ring-bindings can be opened out, and a sketch spread over two pages. Large-format sketchpads are difficult to hold, but they offer more space—you can do one large sketch or several smaller ones on a page. For washes, go for heavy paper or paper with plastic bonding around the edges; light sheets will just wrinkle.

PAPER TYPES
A quick word about types of paper. The cheapest available is going to be very acidic, which means the paper will yellow and get brittle with age. If you want to keep your sketches, it's an important point so unless a paper states it's acid-free, assume it's not.

Watercolor paper is the best to use, and comes in three types of surface:

▶▶ *Hot-pressed is smooth and ideal for fine work, but not so good for color washes (as it makes colors look dull).*
▶▶ *Cold-pressed (sometimes known as "NOT," as it is not hot-pressed) has a light texture that will take broken-up effects well, but is easily filled with solid color.*
▶▶ *Rough paper retains the imprint of the rollers used in manufacture. Fine detail is difficult, but washes show up well.*

◀ STRIKE A POSE
Reference books not only show figures, but details too, such as hands and fingers held in natural positions.

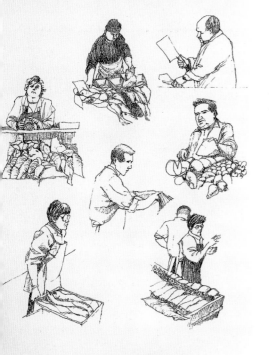

▼ PENCIL DRAWINGS
The pencil drawing of a girl spotted in a market was the basis for a character in a comic strip.

▲ A VARIETY OF JOBS
If you are going to be sketching in one place for some time, pick a site where there's plenty of activity, such as markets or docks, or anywhere with lots going on.

▼ FEATURES
Two studies of faces—one elderly and the other younger. Although done quickly and sketchily, the character and expression come across clearly.

▲ BODY LANGUAGE
This is a good example, taken from life, of how body language reflects emotion. In this instance, the nervous client is waiting for his hectoring lawyer.

◀ SKETCHING WITH PAINT
Watercolors can be used for quick attempts to capture the colors of a scene and the people in it.

OVER TO YOU

▶▶ Talk some friends into letting you sketch them. Try out various poses.
▶▶ Do close-ups, with a range of different expressions.
▶▶ Stick with one expression, but alter the lighting. See how the light can apparently change the meaning of the expression.
▶▶ Find a building near you and sketch it from a variety of perspectives, distances, and lighting conditions. See how its character alters as the way it's presented changes.

GETTING INSPIRATION

The writer Harlan Ellison has his own method for getting inspired—and that's listening. Whether you're in a supermarket checkout or waiting for gas, put your ears on random scan. Filter through all the talk going on around you—but don't actually listen to the conversations. Just pick up on the words. Eventually an odd phrase will grab your attention—and you've got a story title. Often, when you're not fully concentrating on context, you'll mishear the real words, and the bizarre phrase your brain constructs can really inspire you.

▲ IT'S A WONDERFUL LIFE

We know what the immediate effects on George's hometown might have been if he hadn't lived, because the angel Clarence shows him. But what about the broader changes? Imagine how so small a change might fan out across the country.

MOVIES AND TV

Everybody's watched something at one time or another and said "Hey! I can do better than that!" There's nothing like a bad movie to get the juices flowing, especially when one of the characters does something really stupid and it gets you waving your arms in frustration. And there's nothing wrong with a little judicious borrowing here and there (just don't give in to downright plagiarism). Spielberg's *A.I.* is only *Pinocchio* recast with robots, and everyone knows C3PO from *Star Wars* was inspired by the female robot in Fritz Lang's *Metropolis*. It comes down to the "What if?" factor. What if the Id monster from *Forbidden Planet* had somehow survived beyond Morbius' death and escaped Altair IV? What if George in Capra's *It's A Wonderful Life* had still decided to kill himself? Crude examples, but examples of the kind of springboard you can use.

OTHER GRAPHIC NOVELS

The most obvious example of inspiration is from comic books. All of the people involved in the comics industry started drawing their own comics as kids—and usually the characters were ones already in print. It's natural that we want to continue the adventures of someone we've come to love. Unless you want to risk a heavy lawsuit, you can't continue that into adulthood—but at least you've learned something about how it's done, and you've made your own mistakes. Continually reading comics as they continue to mature can only inspire you.

Imagining how a straight novel or short story could be adapted is good. At least someone's taken the trouble to write a plot and story for you already; all you have to do is consider the best way to transfer the original onto the comics page. It's a quick way of learning how both forms of novel differ in their narratives: like movies, comics can't be used to transfer a novel into pictures. The outcome will not be identical, but, then, a faithful adaptation isn't necessarily an identical one.

▲ SPACE OPERA

The style of the *Star Wars* films goes straight back to the days of the *Flash Gordon* and *Buck Rogers* newspaper strips—with a little pseudo-samurai action on the side.

WHAT'S GONE BEFORE
As well as being a source of inspiration and reference, other graphic novels will show what's already been done, as well as current trends.

WORDS, JUST WORDS

The lyrics of most contemporary music are excellent for creating images. Many bands choose to write in oblique ways that hint at the real meanings they intend to convey (often very personal ones), while at the same time provoking images in the listener that have nothing to do with the original intent of the composer. Mercury Rev sing of "the darkness rising"—the title of a novel by the late, great Fritz Leiber. On Golden Smog's *Weird Tales*, the track "Making Waves" is a haunting song that hints of suicide and loss that would make a very powerful graphic novel.

It's a personal thing—two people hearing the same music won't necessarily feel the same emotions or experience the same imagery.

THE POWER OF MUSIC

Listening to music is an obvious source of inspiration. The great composers deliberately wrote to conjure images in their listeners' minds. But it doesn't have to be classical music. We all know how a certain song can make us remember the first time we heard it, who we were with, or what we were doing. The brain's great when it comes to association—but it's also good at creating images out of nothing.

Try writing with music in the background—and not at some turned-down, subliminal volume. Crank it up. Choose the music carefully: rock 'n' roll for the fast-paced action scenes, something weird for when you want to go astral wandering, calmer stuff for the touchy-feely parts. Sing along to the melodies—if you know the words well enough, you can do it without obstructing the creative flow.

OVER TO YOU

Spend some time just looking at and listening to the world around you. Take notes of the things people say and how they say them. Rhythms and repeated phrases are as much a part of a character as actions.

▶▶ *How do people actually talk? In organized and logical sentences? Or in messy, overlapping, often unfinished phrases?*

▶▶ *How would you transcribe a dialect so that it's understandable to the reader, but doesn't come across as clichéd or condescending?*

▶▶ *Try a bit of sleuthing—figure out who people are just from what you see of them. The Sherlock Holmes approach. You won't know if you're right or wrong—it doesn't matter— but you're learning how to create a visual character that others will recognize.*

▶▶ *Read outside your genre—that's an old piece of advice. If you want to write superhero books, go out and read something else.*

▶▶ *Armed with your observations and reading, sit back, relax—play some music if you want—and see if inspiration hits you.*

▶▶ *Write a scene with characters talking naturally—not in the stylized manner of books, comics, and film. Play around with the dialogue until you hit a balance of natural and stylized speech that reads easily but sounds true.*

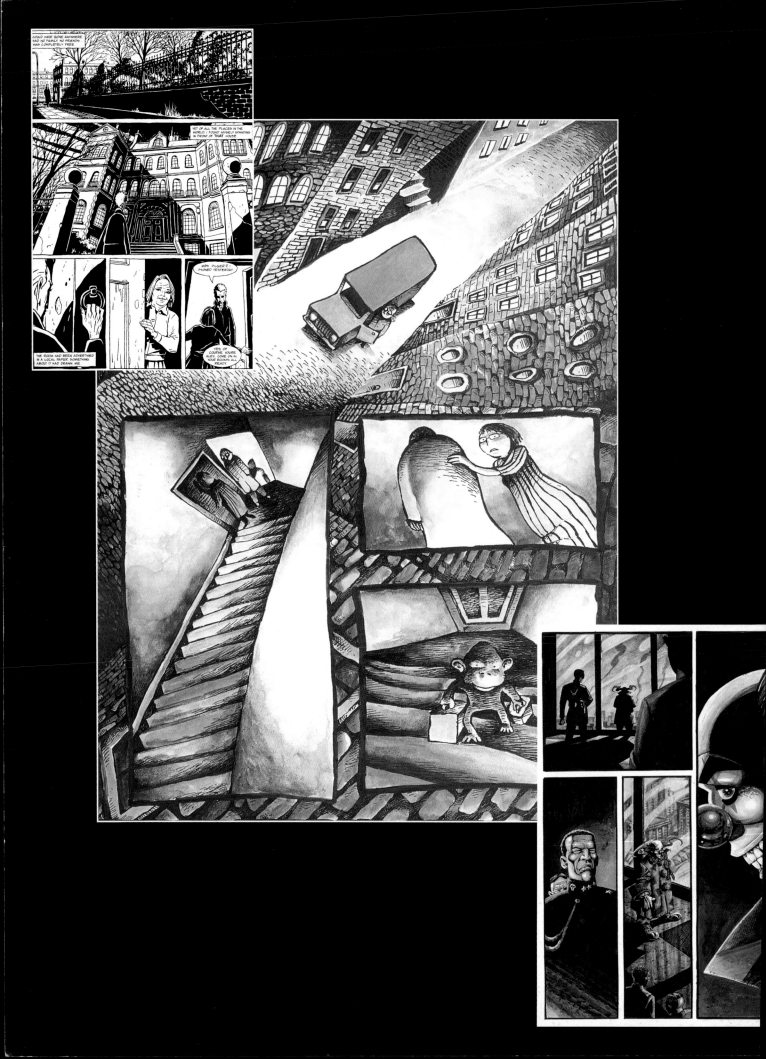

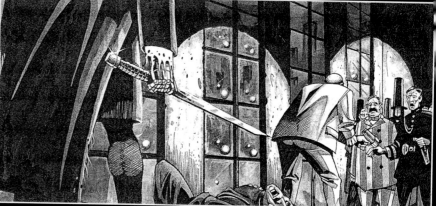

WRITING
THE SCRIPT

The script is an outline that the writer uses to accurately convey his or her image to the artist. There are recognized conventions in the writing of a script, and while there may not be a definitive right way and wrong way—everyone has his or her approach—there's still a framework that all scripts follow.

This chapter details the various ways a script may be written, how circumstances can dictate a particular approach, how to distinguish instructions to the artist from dialogue and narrative, and the best way to actually present your finished script.

Basic Scripting Techniques

There are many ways to present a script, but the commonest methods are full-script and plot-first.

Full-Script

Full-script speaks for itself; it's like a mini-movie or TV script where the writer is also director, producer, and lighting engineer. Well, it's your show—you want to know how it looks, where all the props are, and where your characters hit their marks. The artist may not agree with you (nor may the editor—changes happen everywhere in this business), but you get a chance to stick your two cents in first.

The manuscript page (and that's distinct from the final page) has descriptions of the characters (where needed—you only need to describe a character once after all), how they're positioned in relation to each other, and what they might be doing. Details of the background are only needed for each scene change. You can also throw in who should be in close-up, middle distance, and so on—although these details may get changed before publication. Unless the shot has a particular dramatic relevance (i.e., an extreme close-up), either the editor or artist might decide the scene can be done another way. Then you add in the captions, the dialogue, and the thought balloons.

NUMBERING THE PAGES

Not only should the manuscript pages be numbered clearly—to stop disastrous re-shuffles somewhere along the way—but it should also be made clear which graphic novel page you're on. The manuscript contains directions that will only be seen visually in the final page, so naturally there'll be more manuscript pages than novel pages. You can make a note of the novel page numbering, or alternatively start a fresh manuscript page when you've reached the bottom of the scripted novel's page.

▶ ANALYZING A FULL-SCRIPT PAGE

In this scene from a science fiction story—*The Coils of Alizari*—we have our hero, Pike, escaping from the villains in the nick of time. Note the descriptions of the action for each panel, and the positioning of the captions in relation to where they fit best—after the dialogue or before. There is little or no character description, as that has already been dealt with. However the characterization is maintained (Pike acting selfishly, the onboard computer—Michelle—like a drama queen).

Pros and Cons: Full-Script

PROS

▶▶ *Writers are pretty much in the driver's seat. They know exactly how fast or how slow they want the story to go—where the sudden cuts are, where they want to jump from one plot line to another.*

▶▶ *Writers might change their minds halfway through the writing. They suddenly reach that point where the characters take over and start telling their stories. When that happens, there are bound to be new ideas—so they go back and re-write.*

▶▶ *Your time's your own. No one else to take the credit (or blame…).*

CONS

▶▶ *Once the script's written and delivered, it's too late. It's no good contacting the editor or artist two weeks after you mailed in your script with changes you've just thought of.*

▶▶ *If you're not blessed with a particularly visual imagination, your script might lack descriptions that will help the artist visualize your story.*

▶▶ *If part of the story gets missed at the artwork stage (for whatever reason), working with full-script, you're in trouble. Imagine reading a book that's had a page torn out the center.*

▶▶ *This method is necessarily slower than plot-first. If you're working on a tight deadline, that's an important consideration.*

The graphic novel page number. Every time you start a new page, begin a fresh script page, and clearly mark the page number.

The entire script is double-spaced so it is easier to read.

The script page number keeps the manuscript in order

Each panel is numbered clearly to maintain the story's chronology.

Instructions for the artist (what's happening in the scene, who's in the shot, what they're doing, etc.) are generally done in small case.

Not the way somebody would react in real life: it's a safe and unthreatening sense of peril. Perfect for the tone of the story.

Narrative and speech is rendered in capitals—to distinguish them from instructions to the artist.

Each character is clearly indicated each time they speak.

Each narrative caption is labeled, and presented in the order it should appear in the panel. Number them if you wish.

THE COILS OF ALIZARI / P.28

37

PANEL 35: All three fighters firing at once. The pirate ship is blowing apart. The Zenda is also receiving minor damage.

CAPTION: BUT IT WAS NEVER GOING TO GET CHANCE TO USE IT …

PANEL 36: Pike and the pirate looking through a window at the destruction of their ship. Both Miglians are on tiptoe, also trying to get a look.

MEES: LOOKS TO ME LIKE WE'VE FALLEN ACROSS SOMETHING PRETTY IMPORTANT TO BOTH ALIZARI AND GRIMELIANS, CAP'N PIKE.

PIKE: AND I'VE GOT A FUNNY FEELING I KNOW WHAT, MISTER MEES!

PANEL 37: Pike standing over the navicom again. A holographic schematic of the Zenda is floating before him.

PIKE: MICHELLE! IS THERE AN ESCAPE POD ON THIS MISERABLE WRECK?

MICHELLE: NO NEED TO TAKE THAT TONE, DARLING—OF COURSE THERE IS! SEE: THE PRETTY PINK SECTOR …

PIKE: RIGHT! WE'RE OUT OF HERE—!

PANEL 38: Pike cramming himself through the escape pod's small door. The pirate, Mees, is standing just behind him.

PIKE: WHAT WAS THIS DESIGNED FOR? MIDGET LEPRAKAANS OR SOMETHING?

MEES: HURRY UP, CAP'N! THOSE FIGHTERS'LL HAVE OUR RANGE BY THE NEXT PASS!

PANEL 39: The escape-pod moving towards launch-position. Mees is being left behind. Pike's face, visible through a window, is smiling unpleasantly.

PIKE: SORRY, MEES—ONLY ROOM FOR ONE IN HERE! IF IT'S ANY CONSOLATION, I THINK BOTH ALIZARI AND GRIMELIANS WANT THIS SHIP INTACT. YOU SHOULD BE OUT OF ONE OF THEIR PENAL COLONIES IN A COUPLE HUNDRED YEARS!

CAPTION: A MOMENT LATER, PIKE FLICKED THE IGNITION …

PLOT-FIRST

Plot-first is a method developed at Marvel comics as a timesaving device. It meant that the writer could churn out more titles in a short space of time—probably the only answer at a time when Stan Lee was working alongside such talented artists and storytellers as Jack Kirby and Steve Ditko.

Back then, the plot was just a few pages long, and the artists took it, drew 120-plus panels, and returned artwork for dialogue, captions, and sound effects to be added (in blue pen that doesn't show up when photographed). This was then inked and colored. Nowadays, writers can produce reams of plot for the artist to work on.

▶ ANALYZING A PLOT-FIRST SCRIPT

This is an example of a plot-first script. This part of the script would have been plotted briefly: "…as the situation worsens, Pike flees the Zenda, leaving Mees and the Miglians, and the ship's computer, Michelle."

Sometimes the writer will sketch his or her rough ideas of how a page might look and submit it along with the plot, (see below).

PROS AND CONS: PLOT-FIRST

PROS

▶▶ The artist can do some of the writer's work for him. If all the writer started with was a plot but no real idea about storyline, what he gets back might get the juices flowing.

▶▶ All writers should be able to see each scene in their heads. If the artist produces a piece of art that's far beyond what the writer imagined (and it's not unlikely—if a writer could draw that well, he wouldn't be the writer), that should inspire the writer even more.

▶▶ If the artist slips up and forgets something, like a vital clue in the story's development, the writer can stick in some dialogue or narrative to fill in the gap. It's not perfect, but it's better than leaving a hole in the plot.

CONS

▶▶ The artwork might come back with more action scenes than the writer would like. It's hard to move the story along if a quarter of the novel is taken up with two characters beating the living daylights out of each other.

▶▶ Similarly, the artwork might move the emphasis away from the writer's original idea or alter the pace dramatically.

▶▶ The writer might not even like the artwork. A pro would swallow his or her indignation and finish the book anyway; but it's hard to do one's best work on something one has come to dislike. That's human nature.

AUTHOR THUMBNAILS

Sometimes a writer might know how he or she wants a particular scene to look. It's therefore not unusual for writers to include thumbnails with the script—whether it's a whole page of rough artwork or a few doodles in the margins. The artist doesn't have to adopt all the ideas, but it can be helpful.

To the right, the author of *The Coils of Alizari* has done a full-page rough of the scripted scene. He has shown external to internal shots, close-ups, and rough positioning of characters. He has also included speech balloons and dialogue boxes, which further helps position the cast. The finished artwork will probably look nothing like this, but it's another aspect of the vital communication between writer and artist.

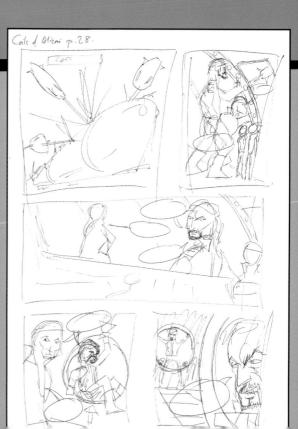

As in full-script, dialogue and narrative is still capitalized. It makes it easier to read.

Always number script pages and note which graphic novel page you're on.

In this example, single-spacing has been used. An extra space between characters' separate lines of dialogue (or narrative) makes it clear who's saying what.

The character names and captions are underlined as well as numbered. This distinguishes the names from the actual printed dialogue, making it quickly and easily seen at a glance.

28

1 <u>CAP</u>: BUT IT WAS NEVER GOING TO GET CHANCE TO USE IT

2 <u>MEES:</u> LOOKS TO ME LIKE WE'VE FALLEN ACROSS SOMETHING PRETTY IMPORTANT TO BOTH ALIZARI AND GRIMELIANS, CAP'N PIKE.

3 <u>PIKE</u>: AND I'VE GOT A FUNNY FEELING I KNOW WHAT, MISTER MEES!

4 <u>PIKE</u>: MICHELLE! IS THERE AN ESCAPE POD ON THIS MISERABLE WRECK?

5 <u>MICHELLE</u>: NO NEED TO TAKE THAT TONE, DARLING—OF COURSE THERE IS! SEE: THE PRETTY PINK SECTOR …

6 <u>PIKE</u>: RIGHT! WE'RE OUT OF HERE—!

7 <u>PIKE</u>: WHAT WAS THIS DESIGNED FOR? MIDGET LEPRAKAANS OR SOMETHING?

8 <u>MEES:</u> HURRY UP, CAP'N! THOSE FIGHTERS'LL HAVE OUR RANGE BY THE NEXT PASS!

The lines are to indicate panels—everything within a line is contained in a panel. In this case, lines 4, 5, and 6.

Note each caption or speech line is numbered. This helps when the panels and bubbles have to be inserted over the artwork. This, in turn, keeps everything in order (no one's talking about something before another character mentions it).

PACE

The speed with which a story unfolds, or its pace, is vital. Too slow and you'll bore the reader; too fast and you run the risk of leaving him or her behind. Judging when you need to vary the pace is also important. You can generate tension by quickening the pace, thereby creating a sense of urgency. More reflective moments—periods when your characters are simply interacting—must be slower. If your central character is investigating a mystery, then he or she needs to take his or her time over it. But once most of the clues are found, that's the time to crank up for the climax.

The way you create that pace comes down to narrative drive. During the leisurely moments, as your central character whiles away the hours with his or her friends, you can sit back and take your foot off the pedal. But such moments shouldn't last too long. Nor should there be too many of them.

INCREASING PACE

The pace is upped once the plot kicks in. Maybe there falling out over something trivial and our hero w out—straight into the main story. Or maybe the s comes knocking on the door in the shape of the l psychotic gunman who's on the run after holding u supermarket two blocks away.

OVERLAPPING PLOTLINES

Incidentally, you can create suspense even while y hero is relaxing. By cutting back and forth between store heist and your guy, you make the readers won why? Obviously there's going to be a link at some po but when and how? Two apparently disparate events going to collide, disastrously for someone. You know the readers know it—suspense is keeping them wai for the other shoe to drop.

INTRODUCING SURPRISES

Surprise, on the other hand, is when Great Aunt Gla suddenly whips out a machete and tries to disembo our hero. It's a great device, but should be used sparir

SIMULTANEOUS STORYLINES

Changing scenes and pace keeps the reader happy. Here's a typical run through of key pages from one graphic novel.

4. Battle ensues.

1. Our hero runs into trouble with some punks.

2. But where are his colleagues? Otherwise occupied…

3. They discover the villains' lair.

nstantly springing surprises on your readers has a
mbing effect—desensitizing, if you will—and the
ock value is lost.

IST ENDINGS

d the traditional "twist" ending, depending entirely on
prise, should never contradict everything that has
he before. Cheap movies do it all the time—but you're
: making a cheap movie, you're writing the winner of
:t year's Eisner Award. The surprise should be true to
 internal logic of the story. Readers should think:
ow—I never saw that coming—but it makes sense..."

XING PLOT STRANDS

've already used an example of two overlapping
ments of the story for dramatic effect. In the above
e, both were strands of the same plot. But it's also
ssible to introduce another plot line—one that's
ordinate to the main plot—and have that running
ngside your main story line.
 Subplots are pretty hard to ignore in fiction. If your

characters have any kind of depth, there will be other
parts of their lives that carry on, semi-independent of the
book's main thrust. If your hero's a superhero, then he
also has a private life, quite separate from his world-
saving activities. If he's a cop, then he has a domestic life
of some kind—be it a family or a succession of girlfriends
that he can't hold on to. The subplot not only adds depth
of characterization, but also tweaks the tension ratio.

KNITTING STRANDS TOGETHER

Separate as the strands are, they must be resolved in
some way before the end. Maybe your hero cop is being
pressured at work—but he's also suffering the stress of
supporting a family. Your readers are voyeurs—they have
the ability to see both threads of his life and will be
wondering which will snap first. Will he lose his family
and job, or will he buckle under the strain and snap?

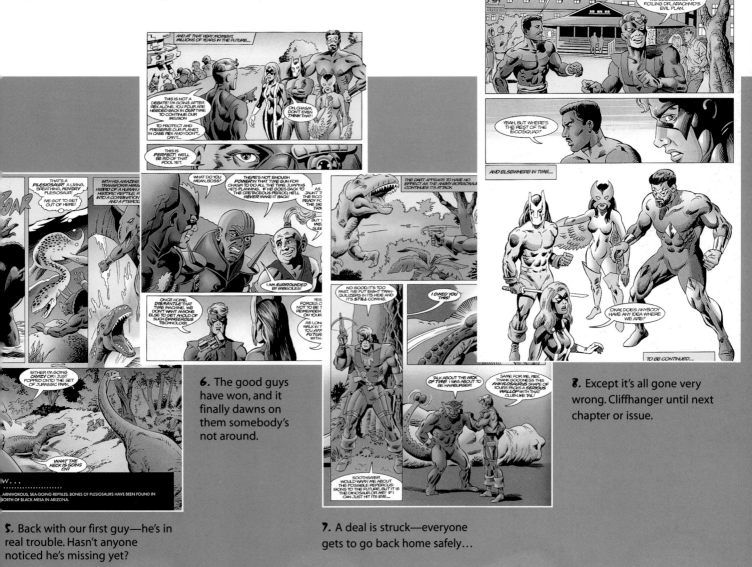

5. Back with our first guy—he's in
real trouble. Hasn't anyone
noticed he's missing yet?

6. The good guys
have won, and it
finally dawns on
them somebody's
not around.

7. A deal is struck—everyone
gets to go back home safely…

8. Except it's all gone very
wrong. Cliffhanger until next
chapter or issue.

Scene Changing

Scene changing is going from one area of the story and characters to another. True—but it's also a lot more. Changing the scene is one of the ways you keep the story moving. When and where you cut to another place can create its own dramatic effect.

You'll be familiar with cliffhangers—leaving the story at a moment of tension or excitement. It's usual to end a season of *Angel* or *Enterprise* on one. Ian Edginton's 13-part mini-series *The Establishment* (Wildstorm) closed each issue with a hook that left you wanting to know what happens next. In a one-part book, however, the hooks are placed as the story unfolds. With more than one subplot firmly in place, you can cut back and forth between them. Cutting back to calm scenes will slow the tension—but cutting between action-packed scenes will crank the tension higher. Frank Miller's *The Dark Knight Strikes Back* (D. C.) contains many brilliant examples of this.

▶▶ SEE ALSO
Framing devices, p. 26

HOW TO SWITCH SCENES

There are a couple of ways you can switch scenes. (1) The first is to have two or more sequences, each filled with mini-climaxes that you can cut between. The only problem with this is that you can exhaust your readers, and it can get a little tedious if you let it go on too long. (2) The second way is to have a fairly calm and uneventful sequence running alongside. A couple of secondary characters, say, just walking through the park, discussing something that appears to have no relevance to the story (but it will—everything has relevance). As a new cliffhanger approaches, we cut back to our secondary characters, still chewing the fat. This not only keeps the tension going with your main character—in real trouble somewhere—but you create another kind of suspense with the two characters. The readers are going to wonder just what relevance they have (readers will know through experience that these characters will have some relevance).

TIME AND SPACE

Running simultaneous subplots and overlapping them allows you not only to create the impression of several events happening simultaneously, but also maintains dramatic tension.

A story line like the cop with problems at work, at home, and the attack on his family that he doesn't know about is an ideal candidate for this treatment. The domestic scenes would be fairly calm, showing his wife coping with the family, her internalized monologues giving away her concerns; the cop at work, dealing with bureaucratic bosses, cases going badly, superiors complaining, professional doubt; the gunmen working up to the hit. All happening at the same time, but in different places. Until the end of the book—when all three strands come together, supplying your climax.

The only time this wouldn't happen is when you're concentrating on one point of view (PoV): a detective, say, when you don't want the pieces to fit until the final scene. Or the band of campers stranded by an old haunted mill, each person dying horribly at the hands of the killer we never see (until the end).

This is linear storytelling—events separated by space, but

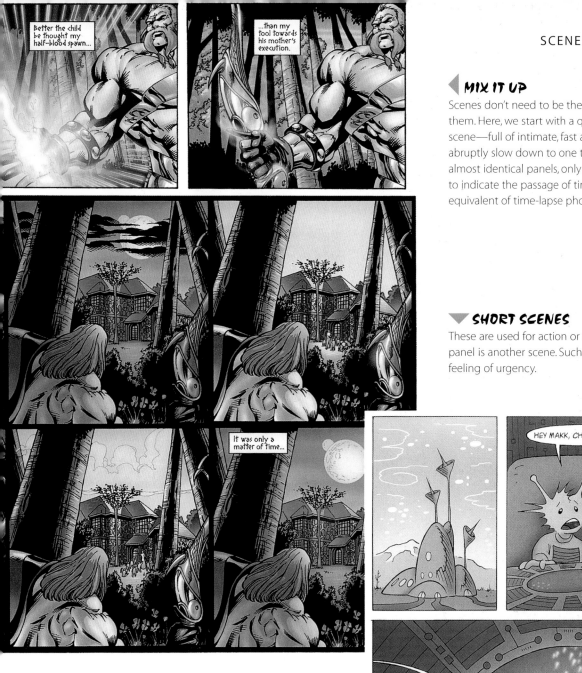

◀ **MIX IT UP**

Scenes don't need to be the same length. Vary them. Here, we start with a quickly moving scene—full of intimate, fast actions—and abruptly slow down to one that lasts hours. In six almost identical panels, only the sky changes—to indicate the passage of time. It's the equivalent of time-lapse photography.

▼ **SHORT SCENES**

These are used for action or surprise. Every panel is another scene. Such rapid cuts provide a feeling of urgency.

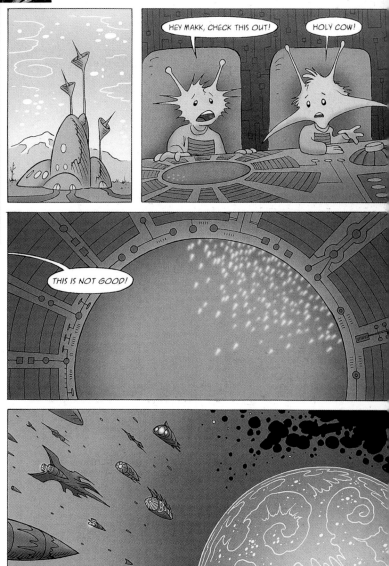

not time. But it is possible to follow a non-linear route, with events separated by time as well. Flashback, flash-forward, flash to events that may not even happen, depending on the outcome of the main body of the story.

A perfect example of this is James O'Barr's *The Crow*. Eric Draven's past life is revealed in a succession of flashbacks, slowly filling in the blanks and providing his motive. Art Spiegelman's *Maus* also uses flashbacks to superb effect. There is no reason why you can't tell your story in a similar way, overlapping events that have some relationship with each other—though happening days or weeks apart. Normally, no one would see the relationships so clearly; but by running them parallel, you make it obvious.

Of course, this method of storytelling isn't as easy as the linear method, but it can be very rewarding. Doing something hard, and doing it well, is one of the best reasons to do it.

EXPOSITORY SECTIONS

Expository sections are where lots of explanations take place. These are going to be long; but people talking isn't very exciting, so you have to hold the reader's attention. This can be done with various devices, such as shock tactics, flashbacks, and so on.

The old woman confirms both the readers' and the main character's suspicions—she is mad. The scene is also intended to repulse and shock.

The young woman backs away. Will she flee before finding out what she came here for? Note the crosses on the wall—a recurring motif throughout.

The main character, a young woman, comes into the room of her old relative. The last panel shows the state of the old woman. This should hook the reader.

They begin to talk. Despite the relaxed mood, there is a certain degree of anxiety about the old woman.

SCENE LENGTH

One final point to make about scenes involves their length. Generally, a scene is as long as it needs to be. There's usually a natural point where you think, "Okay, I'll move on to the next scene now—it feels right," even if you're not jumping back or forth for a reason. But there's another reason to shorten your scenes, and that's pace or suspense.

Those of you who have written straightforward fiction will know one of the easiest ways to speed things up is to use shorter sentences. It quickens the pace. If there's something interesting happening, you don't slow it down with long-winded, highly-detailed, descriptive passages. You get on with it. The same applies to graphic fiction.

Short, fast scenes will provide energy to a story. Cutting rapidly back and forth between separate strands that are drawing together generates a sense of climax. It can also create a sensation of confusion—the characters are being dragged headlong into something they don't understand.

Building steadily to that climax is the key. You start with scenes that are no longer or shorter than ones that have gone before. But gradually you shorten them, cutting down from pages to a single page, then just a few panels, then a line. Ultimately, your final scene could be one page-sized panel, detailing whatever climax your story demands. Vast explosion, massacre, alien expelled into vacuum ... whatever.

A flashback. We begin with a brutal beating, then focus on a crucifix. We see how violent abuse and the martyrdom of Christ have become mixed in her mind.

The crucifix is shown again. We zoom in on the face of the suffering Christ looking down on the old woman. But the last panel has something different; the man from the flashback surrounded by hellish creatures.

ward the end of the page the old oman produces a crucifix—the motif ain—and holds it tight. Note how the ge begins with the old woman in the tance, and ends in extreme close-up. ectively zooming in on her.

The old woman has another flashback, and the final piece of her obsession is revealed; an abhorrence of sex.

The man has taken his revenge and had the old woman committed to an institution. Note the use of windows and light cast through them—this panel is almost a combination of the seventh and fifth panels.

OVER TO YOU

Imagine you have a lengthy scene to tell. How would you write it so that it's not just a collection of dry facts?

▶▶ *Are there flashbacks you can use?*
▶▶ *Can you use shock tactics to surprise the reader?*
▶▶ *Consider how a conversation between two people can be visually broken up by cutting back and forth between them.*
▶▶ *How will you end it? The section has to leave the reader wanting to know what happens next.*

TELLING THE STORY

In regular novels, the story is either narrative-driven or character-driven. Because graphic novels are a visual medium, the method of storytelling will be narrative-driven or visuals-driven. Most graphic novels will be narrative-driven overall—that's to say, the plot dictates how the story develops, and the characters are there to move the plot along. Character-driven novels are more interested in how the characters interact than the overall plot, which acts more as a framing device. It's a much older style; indeed, the original definition of a novel was "...a book whose characters matter more than the story."

NARRATIVE DRIVEN

A narrative-driven story will be exactly that: a tale that will have events unfolding as a result of narrative pressure. One, in fact, where it's almost possible to imagine that the artwork isn't actually necessary. There have been adaptations of novels that were published like this. Trimming the text down, the artwork is then used to fill in the gaps that the adaptation has necessarily left out. Simply put: regular novels have whole areas devoted to description of characters and backgrounds. Taking these out, and leaving the artist to do the job instead, is a way of abridging a novel's length while leaving it imaginatively intact.

▼ TEXTUALLY DENSE

This example relies almost entirely on the text to tell the story. The artwork is there merely for illustration.

Other narrative-driven forms would include something mentioned earlier under plot-first scripting: when an artist accidentally leaves something out of the visuals. The writer then has to insert narrative captions and explanatory dialogue to make up for the visual shortfall. Admittedly, this isn't deliberate; but there are comics where the characters talk incessantly, acting like a Greek chorus, explaining what's going on. A perfect example is in Howard Chaykin's *Time²: The Epiphany*, where whole static panels are taken up by explanatory dialogue. This is, of course, deliberate, used to recreate the *film noir* feel the book is quite obviously aiming for. At such times, the artwork is there as a gorgeous backdrop against which the characters bounce off each other. In the above example, there are no narrative captions, so their role has to be filled by dialogue.

KEY POINTS

▶▶ Artwork isn't subsidiary in a narrative-driven story—it performs quite a different task to a regular visually-driven book. It's there in much the way pictures are there in a movie or TV show. There has to be something against which the story unravels, or a frame from which to hang it.

▶▶ Sticking to narrative-driven all the way through a book would be boring. In graphic novel form, it pays to jump back and forth, interspersing blocks of narrative with visually-driven blocks. It comes back to pacing again, with the narrative parts acting as the slower, introspective or personal moments.

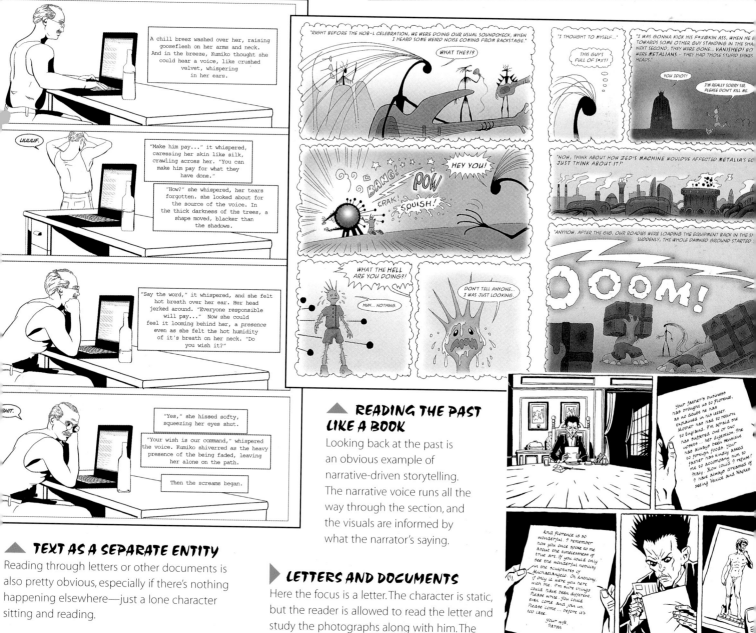

▲ READING THE PAST LIKE A BOOK

Looking back at the past is an obvious example of narrative-driven storytelling. The narrative voice runs all the way through the section, and the visuals are informed by what the narrator's saying.

▲ TEXT AS A SEPARATE ENTITY

Reading through letters or other documents is also pretty obvious, especially if there's nothing happening elsewhere—just a lone character sitting and reading.

▶ LETTERS AND DOCUMENTS

Here the focus is a letter. The character is static, but the reader is allowed to read the letter and study the photographs along with him. The reader has become a participant.

VISUALS-DRIVEN

It could be argued that the vast majority of graphic novels are visually-driven. And that is, in part, true. It's a visual medium, after all.

But are they all visuals-driven?

To answer that you have to use a simple formula, one that can be adapted for many uses in writing. If you remove X, does the story still work? In this case, X is the visuals. Take a comic—any comic—and apply said formula. Will this work if the visuals are removed? You'll probably be surprised to find the answer, in many cases, is yes. Denny O'Neil's *Batman: Nightfall* sequence was adapted very successfully into a regular novel (in fact two—one version for adults, one for younger readers) and a radio play for the BBC in Britain. The lack of artwork didn't stop the story from working. *The Death of Superman* was also novelized—with less successful results.

So, how do you get a story that's so dependent on the artwork it can't survive without it? Simple—don't have any captions or bubbles. In the early 20th century, Frans Masereel and Lynd Ward were both producing woodcut narratives that were entirely free of words. More recently, Eric Drooker has received great critical acclaim with Flood (about a biblically-flooded New York) and *Blood Song* (about a girl and her dog; who flee soldiers in a jungle to a big city). Both are wordless, graphic narratives (*Blood Song*'s subtitle is *A Silent Ballad*) that are more like graphic poems than novels.

Under normal circumstances, however, you would use words and visuals. It can be very powerful to have a section of a story with nothing but visuals. A shadowy figure moves down a dark alley; in one hand is a huge knife. At the far end of the alley, growing clearer as the figure nears, is a lone woman, standing in a poorly-lit street. No words are necessary. Even if this is meant to be a piece of misdirection, and the writer's playing on our preconceptions, it still works as an image.

▲ THE LANGUAGE OF DREAMS

A dream sequence is an obvious example of purely visual storytelling. Dreams are often silent—and even if they weren't, the lack of any narrative voice or dialogue makes them spookier.

▶ THE SILENT TOURIST

With no narrative text to color our expectations, we experience it just like the young female; and judging by the expression on her face in the last panel, this is all new to her.

Mix it up. Imagine two separate sequences in a book—two strands of the plot. One is told conventionally with dialogue and narration, the other is told visually. This would be a very powerful way to tell the story. With the visual sequence, there's always the possibility of things not being quite as they seem. Once again, the writer can play with the readers' preconceptions, creating tension throughout the book, and surprise at the end when things turn out very differently.

▼ **TRAGEDY**

Some things are too big for words—such as the destruction of a world, as is happening here. We can fill in the blanks from our own fears and experience.

▲ **THE OLD DARK HOUSE**

Perception is skewed in this example: the artwork is strange and dreamlike. The expression on the girl's face completes the nightmare, as she glances back at what's bringing up her luggage.

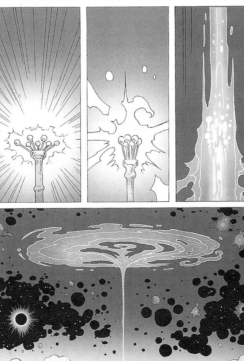

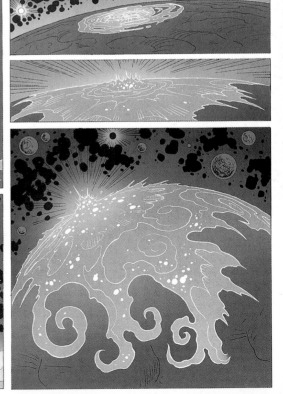

WRITING STYLES

Depending on your story, you'll be adopting a specific writing style. Unless it's a deliberate spoof, you won't be writing a horror story in a light, jokey manner. A space opera done in the Gothic style of Edgar Alan Poe would be inappropriate, albeit interesting.

▸▸ **SEE ALSO**
Style of artwork, p.72

SUPERHERO AND SCIENCE FICTION

▸▸ Originally, superhero fiction was pure escapism. By the 1960s, Marvel gave us flawed heroes. Chris Claremont's work on the *X-Men* used being a mutant as allegory: friendship, social stigma, and intolerance.

▸▸ The Denny O'Neil/Neal Adams period on D. C.'s *Green Lantern/Green Arrow* dealt with topics like drugs and racism. The events of 9/11 were tackled in *9-11 Vols. 1 & 2* from Dark Horse, Chaos!, Image, and D. C.

▸▸ Science fiction doesn't have to be in the far future. Alan Moore and David Lloyd's *V for Vendetta* (D. C.) is set in a future Britain under a totalitarian government—but the erosion of freedom in our own lives is its real theme.

▸▸ Science fiction deals with our fear of change—whether it's aliens, new technology, or an entirely new society.

FANTASY AND HORROR

▸▸ Both fantasy and horror—regardless of whether contemporary or Gothic—deal in the unreal. But at some point—you have to cross with reality.

▸▸ All horror starts off from a mundane base before gradually wrapping the grotesque and scary around you. Even in Gothic fiction reality is not too far away.

▸▸ If you're writing High Fantasy—with all those elves and pixies and dragons and noble quests—there still has to be a connection for the reader, such as a young hero for young readers.

CONTEMPORARY HORROR

▸▸ Contemporary horror—like its far less strange twin, crime fiction—is a reflection of modern life. While crime will meet certain facets of our world head on, modern horror disguises all too real terrors with a supernatural mask. *Preacher* (D. C./Vertigo) is a prime example.

▸▸ Faceless, unaccountable governments, serial killers, child killers, and terrorism—everything we fear but feel helpless against. In fiction at least, we overcome them.

GOTHIC HORROR

▸▸ This is bizarre, drifting into a world where normality is warped into something strange and unrecognizable. Think of the Dreaming in Gaiman's *Sandman* books—a realm that only makes sense when we're asleep.

▸▸ Gothic fiction has a grim, fatalistic feel to it. The strange twists of the story take us all deeper into doom.

▸▸ The central character in Gothic fiction is usually being acted *upon* rather than doing the acting. He or she is an actor in someone else's play, and will only come to impose him- or herself upon the story at the end, when he or she escapes it.

▸▸ Art reflects the decadence in the writing, departing from normal layouts to scenes of chaotic madness.

▸▸ Are the characters mad, or is the narrative? Or is it the entire universe depicted by the story that's insane?

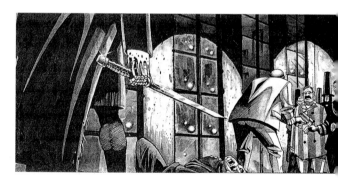

▲ **DARK AVENGER**
Does the sword belong to a grim savior? Or are the couple in even bigger trouble?

◀ **THE HORROR**
A pretty typical scene that could be used in either a horror or dark fantasy situation.

HUMOR AND IRONY

Humor is very subjective; but, if the author's intention is comic effect, we can classify the story as humorous. Irony, however, is a celebration of the perverse—saying one thing but meaning another. The following story isn't meant to be taken seriously. The humor is broad, but the irony comes in the shape of the hippy aliens who would never deliberately hurt anyone, actually putting a character in real danger with their well-meaning intervention.

Bizarre events—but not essentially threatening. More whimsical and surreal.

Fangel is a pompous sort. It will show in his speech. Both Fangel and Kappit have odd names, though not necessarily cute ones.

The narrative has been split over two panels, even though it's effectively one sentence. This can be done purely for effect—or give the narrative a wry, slightly-knowing air (appropriate for this particular story).

Comedy characters—hippy aliens. The dialogue and slang is deliberately out of place (and dated).

More surrealism. The weird colors tell you you're not in Kansas anymore, as well as giving a sinister feel that tweaks up the tension.

Narrative supplying what we can't tell from the artwork—that the world around is silent.

Not the way somebody would react in real life. It's a safe and unthreatening sense of peril. Perfect for the tone of the story.

THE INDOLES p.22

PANEL 93: The magical spores weaving spells around Kappit and Fangel. Doves are appearing out of nowhere; one is trying to saw Kappit in half—and so on.

KAPPIT: WELL—I DID WARN YOU...

FANGEL: I HOPE THEY'RE MORE STABLE THAN YOURS, KAPPIT!

PANEL 94: All of the spores exploding—but with magical force. Everyone is ducking—but one of the Indoles has been turned into a rabbit.

BLOCK: A MOMENT LATER, FANGEL GOT HIS ANSWER—

PANEL 95: The planet from space. Another hole is appearing through it with a flash.

BLOCK: —AS ANOTHER GAP IN THE PLANET APPEARED...

PANEL 96: The two surviving Indoles looking into the new hole—next to their home. There's no sign of either Kappit or Fangel

INDOLE 1: OH MAN—THAT'S ALWAYS HAPPENING! WHAT A BUMMER!

INDOLE 2: YEAH—SORRY, MAN!

PANEL 97: Kappit sitting on a huge wedge of rock, floating under a bizarre, very un-normal sky. It's boiling with vivid colors—crimson, orange, and shot through with a dark purple that has very sinister overtones. Kappit looks very lost and afraid.

BLOCK: BUT KAPPIT DIDN'T HEAR ANY OF THEIR APOLOGIES. IN THE SUDDEN SILENCE, HE DIDN'T HEAR MUCH OF ANYTHING...

KAPPIT: WHERE'D EVERYBODY GO? HELLO—FANGEL! CAN ANYBODY HEAR ME...?

QUESTIONS TO ASK YOURSELF

1 Is the story contemporary or genre?

2 If genre, which—superhero, science fiction, horror, or crime.

3 Does it actually fit a genre pigeonhole (and will this affect your chances of interesting a publisher)?

4 What's the best setting for the story—past, present, or future?

5 If the past, will you be able to research your chosen period adequately?

6 What tone will best fit the story—humorous, bleak, or hard-edged?

7 What mood do you hope to convey?

8 Most important, is it too similar to something already published?

FANTASY

▶▶ Although the world of a fantasy story will not be our own, there are usually plenty of resemblances.

▶▶ The Hyborean Age of the *Conan* stories is similar to the medieval kingdoms of Europe and the Middle East. Whether you prefer Barry Smith or John Buscema, or any of the others who have tried their hand in Marvel's *Conan* titles, all have drawn a world we recognize.

▶▶ Magic works (usually for evil), and magicians frequently summon hideous creatures to do their bidding. This is the major difference from the world we recognize.

▶▶ It's the clash of the familiar with the strange and scary that marks fantasy. Conan may be a hugely strong barbarian, but he's still just a man, pitted against the hordes of hell.

CRIME FICTION

▶▶ Crime fiction usually demands a harsh, no-nonsense tone.

▶▶ Modern crime fiction has a contemporary setting.

▶▶ No one believes in the genteel detective story anymore—we're all too cynical. Hard-boiled doesn't begin to describe it. Frank Miller's *Sin City* books (*The Babe Wore Red*, *Silent Night*, *A Dame to Kill For*, to name a few) are uncompromising and brutal. Modern ultra-violent takes on the classic *noir* style (as you can probably tell from the title).

▶▶ Your style will have to be as brutal as the characters in your book. First-person narrative has an admired pedigree in this genre—but it's become so stereotyped that to get away with it, you've got to get it right.

▶▶ The crime story is about the world we live in, and it will reflect all that's bad along with all that's good. Whether you go for world-weary cops or idealistic investigators, both writing and artwork will be as violent and unforgiving as the subject matter.

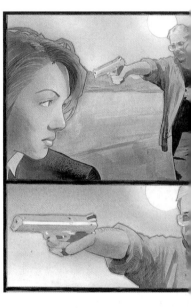

▶ **CRIME AND PUNISHMENT**
A woman threatened by a man with a gun. Which leads us to the next question: is he the bad guy?

▲ **FANTASY**
It's all here—the threat of evil magic, the odd, slightly threatening landscape, and strange creatures.

OVER TO YOU

▶▶ *Try to develop a style—your own, recognizable voice. There's no way this can be taught—it's simply something that happens with time and practice.*

▶▶ *Imitate the styles of your favorite writers—their little tricks, their favorite phrases. Through imitating you'll learn how they tell a story—how they say what they want. After a while, you'll find yourself using tricks and phrasing entirely of your own.*

▶▶ *Write a story in different styles—sparse and modern, florid and Victorian, moody and atmospheric like a horror story. See which one fits best. Or do the varying styles highlight different aspects of the story and change its angle?*

MATTERS OF GRAMMAR

There are various grammatical styles for graphic novels, and their main difference from regular novels is in brevity—you need less text when you've got the pictures doing half the work for you.

THIRD PERSON

The most commonly used style is the third person. The narrative is omniscient—it knows everything that's happening. Even more so than in a regular novel, in which you concentrate on a single point of view, and change it only between chapters. In a picture strip, you normally don't concentrate on one point of view.

e.g. Stan looked across the street, letting the traffic become a blur. There was a flash of dark blue by the intersection... Joanie? He imagined it could have been her coat—but he knew it could have been a cop, too...

FIRST PERSON

First person is less common, but it's ideal for the man alone story. The readers know everything about your central character, but nothing about the others except what they say. A perfect style for crime and mystery stories, although it's not so good for horror. If your central character is telling the story, it's already clear he or she survives whatever terrors are about to descend on him or her.

e.g. I looked across the street. The midday traffic was a noisy blur that streaked by, too quick to focus on. I thought I saw a flash of blue at the intersection—the kind of dark blue Joanie liked to wear. But it was the same kind of blue the cops liked, too...

SECOND PERSON

Second person is a great one for a slightly offbeat feel. "You do something" as opposed to "you did something." It almost puts readers into the role of omniscient narrators—they are telling the characters what they think should happen. Again, it's best to stick with one PoV—it can get very confusing if you've two or three characters all being referred to in the second person.

e.g. You looked across the street, not letting the midday traffic register as anything other than a blur. You saw the brief flash of dark blue at the intersection and thought of Joanie. You knew it was the kind of color she liked to wear; you knew it was what cops liked, too...

PAST OR PRESENT TENSE

Past tense is by far the most common tense—the narrative relating events that happened a day, a week, a year ago, and all the above examples are in the past tense. Present tense is used when you're trying for an effect. Mixing up narrative tenses within a story can heighten certain moods; most of your book is in third person past tense, but whenever a certain character comes on, you switch to third person present tense. Immediately, you have a sense of dislocation.

e.g. Stan looked across the street, letting the midday traffic become a blur. There was a flash of dark blue by the intersection... Joanie?
She watches Stan, sees his sudden confusion, enjoying it. Do you recognize me? she wonders. Or will you convince yourself I'm someone else? Something else? She smiles—a smile as cold as sharp steel.
Stan imagined it could have been Joanie's coat—but he knew it could have been a cop, too...

BRIEFING AN ARTIST

Graphic novels are a visual medium, so a character's appearance is very important. There must be something in the portrayal of a character that gives instant clues to his or her nature. John Constantine dresses habitually in a shabby raincoat, chain-smokes, and stands hunched; instantly we can see that this is a man who is unhappy with the world. Batman is draped in black and hides in the shadows; here is someone who could be hero or villain.

The author usually gives notes to the collaborating artist describing each character; clothing, hair, any obvious physical features, emotions that could be conveyed through the artwork. A good character description will allow the artist to easily visualize what the author imagines, while leaving enough room for the artist's own interpretation.

If you are both drawing and writing the book, it is worth considering what comes first—the artwork or the words. Will your characters evolve as you draw them, or are they already carved in stone?

CHARACTER DESCRIPTION

An author's character description for the artist needs to be clear, to be concise, and to have a strong visual element. It should describe appearance and personality, explain something of the character's origins, and give an indication of any significant events in the story.

▶▶ SEE ALSO
Drawing from a script, p. 86

(a) Visual clues for the artist: Details that will make sens[e] later in the story.

(b) Indicating the period is very useful. Even if the auth[or] has no idea what the fashion of the time would be, the artist can research it.

(c) Another visual clue—the character's body language will give the reader a hint before he or she has read the first line of dialogue.

(d) Although clearly defining the character, this description allows plenty of room for the artist's input.

GOOD CHARACTER DESCRIPTION

Title: From *Quietus—On Earth as it is in Heaven*
Character name: Mantix
Description:

Apparently human, but is in fact a manifestation of a creature from beyond time that has taken on mortal form to die. **(a)**

His clothing is early 19th-century (around 1820), and that of a gentleman. **(b)** His first appearance is at Byron's Villa Diodati, so his wardrobe should look more European than English (if there's an obvious difference). He is impossibly handsome, with thick black hair and long sideburns. He is clean-shaven. He should be more Byronic than Byron—his eyes hint at cruelties and emotions far beyond human.

He should be arrogant, his stance reflecting the contempt with which he regards humanity. **(c)** Above all, despite his form, there should be a strong hint of unearthliness about him. A feeling of power barely restrained, a sardonic humor. **(d)**

BAD CHARACTER DESCRIPTION

Title: From *Quietus—On Earth as it is in Heaven*
Character name: Uryamiel
Description:

An angel **(a)** who responds to Dr. Dee when summoned. He predicts the future—or a kind of future **(b)**—but seems to be holding something back. Even Dr. Dee feels he may be untrustworthy, but the doctor continues to use him. **(c)**

(a) Hardly a full description, it tells the artist nothing of the character's appearance. Is he male or female? Winged or not?

(b) Something of the character's motives, but not enough. Will these predictions have bearing later on?

(c) There is no visual description, only vague character traits that the artist cannot draw. The descripion also fails to mention that Uryamiel is another immortal creature like Mantix, and that there should be visual clues to this from the start.

CHARACTER SKETCHES

The artist has taken the author's character description for the character called Mantix (see left), and developed sketches and final artworks that are a testament to the value of a good brief and successful collaboration. The artist has brought his own unique interpretation to the project.

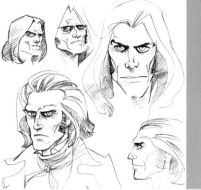

◀ THE INITIAL ROUGHS

The artist is quickly putting ideas on paper as they occur.
▶ *Note the differing hair styles.*
▶ *Experimenting is the only way to get the right look.*

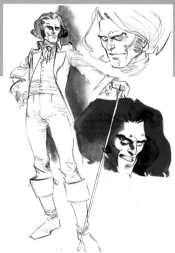

▶ DEVELOPING THE CHARACTER

A trial run of the whole figure, with attempts to capture the arrogant stance.
▶ *Does the character look better with a short coat?*
▶ *Sketches to capture Mantix's cruel expression.*

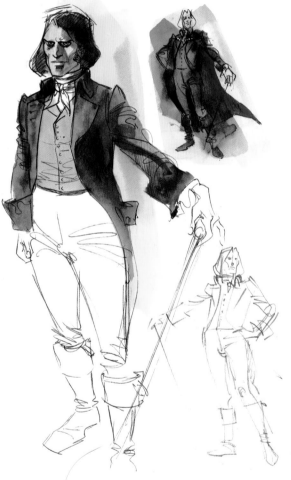

▲ ALMOST THERE

The roughs have evolved into something much more complete.
▶ *Facial close-ups clearly depict Mantix's sardonic expression.*

▶ THE FINAL DRAFT

The figure captures Mantix perfectly—his arrogance, disdain, as well as the sense of power that emanates from him.
▶ *Clothing reveals the period instantly.*
▶ *Head half-turned is haughty—but the eyes and mouth are amused and cruel.*
▶ *Leaning on the stick with hand on hip radiates self-assurance.*

WRITING REALISTIC CHARACTERS

We've touched upon this earlier—considering what your character wants and why he does the things he does. Now is the time to figure out how you're going to do this.

ACTING UNDER PRESSURE

Actions are the first thing that gives a character away. The kind of person you are will always be revealed by the way you act under pressure. Because you're going to be putting your hero through hell before the book's ended, it's a good bet he's going to be giving himself away all over the place. Heroes don't buckle under pressure, and neither do decent villains. Where would be the fun in a bad guy giving up after his first whupping at our hero's hands?

Other characters will cave in to a greater or lesser degree depending on their position in the great scheme of things. The bad guy's minions can be a cowardly lot, or at least more interested in number one than anything else. The hero's friends will also be prey to doubt and fear (as will your hero—the difference is, he doesn't show it). But don't go making the girl some screaming Fay Wray clone or—at the other extreme—a stubborn Lois Lane who consistently gets into trouble and has to be rescued all the time.

VISUAL CLUES

Next, you'll have visual clues to your characters' natures. Readers will need signposts along the way—and a degree of consistency from the artist. We can't expect characters to always stay in the same clothes; so features—hairstyles and even the way they stand, for example—shouldn't change.

Costumed superheroes are often several inches taller than the ordinary guy, so they'll stand out even when they're not in spandex. The villain shouldn't look villainous; instead he'll give himself away by subtler means. There should be a sense of menace around him—even when he's at his most genial. His true nature will be revealed only in private; but luckily, our omnipresent readers will be able to listen in on such moments, and not be fooled at all.

▶▶ SEE ALSO
Characterization, p.30
Body language, p.108

▼ **THE SUPERHERO TEAM**
Superheroes all have distinctive abilities and are clad in spandex.

HEY KIDS, WANT TO FIND OUT MORE ABOUT THE ADVENTURES OF ECOSQUAD? READ ISSUES 1, 2, AND 3 OF THE CANYON COMICS™ SERIES, AVAILABLE FROM THE GRAND CANYON ASSOCIATION AT (800) 858-2808. HAVE MOM OR DAD CALL TODAY!

THE HERO

▶▶ Basically honest (within his own terms of reference—and you can stretch them out quite a bit).

▶▶ Self-sacrificing. This is what raises him or her above the common herd—that willingness to sacrifice himself (herself) for an ideal.

▶▶ Always resourceful. We don't want to get into the "one bound and he was free…" arena, but your hero will always be able to dig himself (herself) out of a hole. Whether it's specialist knowledge, a special talent, or just plain stubbornness, he'll (she'll) prevail—somehow. And remember: it's how he (she) faces adversity that counts.

▶▶ Pretty sure of the difference between right and wrong. Something of a gray area today—moral ambiguity isn't to be avoided. Doing bad things for a good cause, especially if it causes some self-doubt (always good—don't overdo it) and/or a rift between the good guys. Which brings us to…

▶▶ Moral conflict. The hero sometimes doubts the rightness of his (her) cause. This is because your good guy has a conscience.

THE SUPER VILLAIN

The villain here is clothed in garish style. He has minions, a base of operations, and likes the dark. He also appears to be a little unhinged.

BODY LANGUAGE

It's fun to play around with your characters, to try and disguise what their true motives are.

When anyone lies for example, there are certain signs to look for. They often can't meet your eyes directly (though this isn't always the case—depends on how good a liar they are), the pupils dilate a little, and breathing changes, as does the pulse rate. They sweat a little, too, which is what polygraphs rely on: the increased conductivity of the skin. Which is all very well, but how do you portray all that in a graphic novel?

Well, of course, you can't. Not all of it. It'll be up to you, the writer, to think of ways in which you can convey to the reader that your character's been economic with the truth. And, remember, these have to be ways the artist can actually draw.

It'll be down to subtle positioning of the body—failure to meet someone's eyes, looking away, hunching of the shoulders, or keeping to the shadows. All gestures that come under body language—that collection of unconscious signals we make to each other (and spookily, we understand—all without knowing it!). For the purpose of your book, such gestures will have to be exaggerated to make them obvious—to be sure the readers see what you want them to see.

E VILLAIN

he graphic novel villain has very little doubt in his (her) own abilities or auses. Most are megalomaniacs. They may not actually be classifiably nsane—but they're certain to have a few tics. Psychopaths and ociopaths are usually loners, which makes them much harder to detect. lso resourceful. In the course of the book, his (her) plans will be upset everal times by the hero—he (she) will adapt and improvise. ery rarely self-sacrificing (unless love throws a spanner in the works— hat can be interesting). The villain regards his (her) troops as cannon- odder: if there's a problem, he'll (she'll) think of ways for them to solve it. lso sure of the difference between right and wrong: he (she) is right— veryone else is wrong. He (she) may not see himself (herself) as evil— eal bad guys never do—but as simply carrying out necessary work.

E	SEX	HAIR	EYES	HEIGHT	CLOTHING	CHARACTER CHANGES
Boser	Male	Black	Blue	5'0"	Jeans & sweats	Jim's friend, has no direction, ends up saving everyone
ames	Male	Brown	Blue	5'11"	Gray suit	Begins as indifferent to outside, ends up sacrificing himself
a Lannock	Female	Black	Black	5'7"	Black catsuit	Aggressively independent, learns to unbend
	Female	Brown	Brown	5'4"	Grunge look	Bryan's girl, mouthy but kindhearted. She's Brian's moral compass
am Fell	Male	Blond	Blue	6'0"	Dark suit (not black)	The villain, urbane but ruthless, has something on Jim

CHARACTER NOTES

With several characters running around your story, it's a good idea to keep some form of card index on them. It should contain basic information: height, looks, usual clothing, and any changes that are due to take place over the length of the book.

SETTING

You need to consider your setting carefully. Sometimes it's obvious: crime and superhero stories both have huge ties to the big city. You also need to decide on whether you're setting your story in the past, present, or future.

▼ CRIME

Most contemporary crime fiction is set in the present day. Modern cities—with their dark alleys and impersonal architecture—are ideal breeding grounds for crime. This is a typical setting—out in the streets, in the rain, with characters who feel marginalized by the city. The towers are symbolic—they might be shining light, but it's so far above the heads of the characters in the street below that they might just as well not bother.

▲ SCIENCE FICTION

Here we have the key ingredients of science fiction: the future; some alien society that's far ahead of ours; fantastic technology; and space ships. To complete the picture, strange creatures and robots, and just like here, it's common for the society to have a strong militaristic background.

▶ **FANTASY**

Fantasy is more often than not placed in a phony medieval world, usually some Hollywood idea of ancient England. But it doesn't have to be so. Generating a clash between ancient and modern, as a fantasy world—often the world of Faerie—bleeds into contemporary society, has great possibilities and has been used several times—often as a mild satire. Doing the same, but with the Faerie coming up against the clinical, stainless steel, hi-tech world of the future would be even more fascinating. Fantasy and science fiction going one-on-one. It's a thought.

▼ **GOTHIC HORROR**

The mainstay of Gothic fiction: the old, rambling mansion. Usually decaying, parts of it often leaning at dangerous angles, it's a metaphor for the decadent world the protagonist will soon find himself (herself) in. The grounds beyond will almost certainly be just as disturbing. It's as far removed from the normal world as you can get.

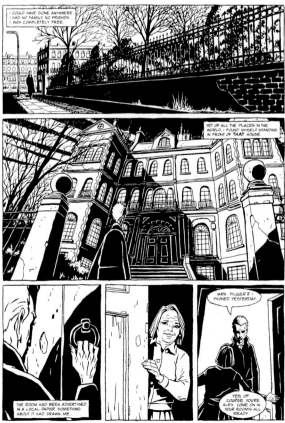

▲ **HORROR**

The best horror is often contemporary—a mundane setting is contrasted with the arcane rite being enacted there.

LANDSCAPES OR CITYSCAPES

Landscapes and settings can suggest their own stories. The weirder ones are the most obvious (and suggestive). But more down to earth locations can be just as evocative. Look around your own town or city. Ignore the bright shiny parts. Look at the areas where civilization has eroded a bit; the run-down streets, the dilapidated warehouses, the crumbling housing. What kind of story do these conjure up? Crime? Drugs? Or the simple human despair of decent people living each day as it comes?

▼ **LANDSCAPE**

A typical rural landscape. An idealized picture where all is at peace. Which is where the corrupting mind of the writer comes in.

◀ CITYSCAPE

Here is the concept of a cityscape taken to its nightmarish conclusion. This illustration strips away perspective and personal space.

▶ FUTURESCAPE

This suggests the sparkling vision of tomorrow's vast cities. Bright, sparkling—but are they just as soulless? Think of the nightmare city of Lang's *Metropolis*.

RESEARCH

You can't escape it—sooner or later you'll have to do some. Did you think you could go on making it up for the rest of your life? What will you do when you want to know how long it takes for a plane to fly from Hong Kong to Buenos Aires? Or when you're illustrating a script that has a Dornier DoX flying boat in a couple of panels? Do you know what one looks like? You're going to have to look it up.

THE INTERNET

Reasonably fast, everyone has access to it, the Internet seems to have the answer to everyone's problem. Except, of course, it doesn't.

The Internet can only return the data that's been entered into it. Esoterica can be found by the bucketload; but sometimes basic, hard facts are much harder to come by. If you don't ask the right question, or aren't quite sure what it is you're looking for, you may spend valuable time looking for web sites when you should be writing or drawing.

▲ READ WIDELY

You can find books and magazines on just about anything these days—from dinosaurs to robots, and anything in between. Popular science magazines keep you up-to-date with research and discoveries.

SPECIALIST PUBLICATIONS AND ORGANIZATIONS

There are magazines dedicated to just about every kind o pastime imaginable: guns, music of all kinds, bike automobiles, fishing. A search through your loc magazine store should result in something useable. T keep up with trends and research in the scientific field you can't beat *Scientific American* and *New Scientist*.

If whatever you're after doesn't have a magazin dedicated to it (and it must be pretty out there if it hasn't chances are there's a society or guild that covers it. Thoug in a pleasing, circular kind of logic, the only way you'r likely to find contact addresses for such organizations through the Internet or in the public library.

◀ BE SPECIFIC

When searching the Internet, try to keep your parameters specific—you can waste a lot of time ploughing through information you don't want.

LIBRARIES

The next line of research. Libraries have computers, of course, and microfiche—and some still have books. Many also have the old-fashioned card filing system, which can be just as infuriating as a slow search engine. But at least libraries have staff, and they should—in theory—be able to direct your inquiries to the right area. Even if the library doesn't have the particular book you need, there should be a library database so you can tell if another branch has a copy.

▲ THE REAL THING

If your book's set in a specific historical period, you need to make sure the costumes are right. Study books about costume or look at paintings from the period.

... the right way ...

.... and the wrong way ▲

▲ ACCURACY

The illustration above represents an officer of the Confederacy during the American Civil War, but there are a couple of errors. Most glaring is the 1870s revolver instead of an earlier ball and cap model. His hat is also wrong. Instead of the fancy, plumed-and-cocked hat one would expect, we have a modern Stetson—familiar to Country-and-Western stars and weekend cowboys alike.

CHECK THESE OUT

A few web sites that will help you with the kind of detail you don't find in everyday life—but might need. Don't think of these as definitive—just good examples.

▶▶ **http://alpha.furman.edu/~kgossman/history** An inclusive reference for the history of European fashion. Includes representative artwork as well as images of the period.

▶▶ **http://www.netsword.com** A forum for all those interested in Medieval and Renaissance weaponry. Includes many links to similar sites.

▶▶ **http://inventors.about.com/library/inventors/bgun.htm.** A site dedicated to firearms; both ancient and modern. A collection of essays on many topics.

▶▶ **http://www.wpafb.af.mil/museum/** The site of the United States Air Force museum at Wright-Patterson airbase. Example of planes from WWI to the present day, with color images, histories, and technical specs.

▶▶ **http://auto.indiamart.com/cars/carhistory. html** Contains images of cars, both ancient and modern. No excuse for not knowing what a 1947 Tucker Torpedo looks like.

CHAPTER 5

ILLUSTRATING THE SCRIPT

In this chapter, you'll learn how to follow an author's brief and translate words into pictures by getting the most out of color, illustrative techniques, and page design. Also covered are the concept of drawing from a script and the various styles of artwork you will need to consider.

STYLE OF ARTWORK

By definition, all graphic novel art is stylized. Over the years, various stylizations have become accepted as the norm. They're a kind of shorthand, so the readers know what they are about to read even before they read the first line.

STYLE AND SUBJECT

Certain stories are going to "speak to you" in terms of wanting to draw them the minute you read the first line. A comedy story won't necessarily demand a cartoon style—dry, social commentary will probably best be handled with more conventional art, while broad slapstick is definitely going to warrant surreal cartoons.

The same goes for superhero strips. If your main character shares the same sense of understatement as the Hulk, for example, the over-the-top, city-wrecking method of a Jack Kirby would probably be best. If, however, you're after the kind of social commentary that Dennis O'Neill brought to the *Green Lantern/Green Arrow* team of the late 1960s, then the more realistic approach of Neal Adams would fit better. Alan Moore's *The Watchmen* imagined what the world would be like if superheroes actually existed, so Dave Gibbon's simple but realistic art reflected this well.

▲ SUPERHERO

Exaggeration and hyperbole are the keys here. Costumes will be bizarre, the male characters will be hugely muscled, and the women are usually curvaceous with legs that go on forever. Characters are always posed dramatically—and often in poses that defy normal anatomy—but it's all about drama. Explosions are bigger and louder, fights are more brutal. Our hero above is a perfect example.

▶ CARTOON

You pick up the paper and there's *Peanuts*. Schulz's instantly recognizable artwork tells you not only what the strip is, but also that it's going to be funny.

This bizarre group (right) falls into the cartoon category. Obviously it's science fiction—but funny science fiction. The little heroine may look worried, and certainly the creatures surrounding her could be menacing, but they're all rendered in such a kooky way that any sense of a real threat is nullified.

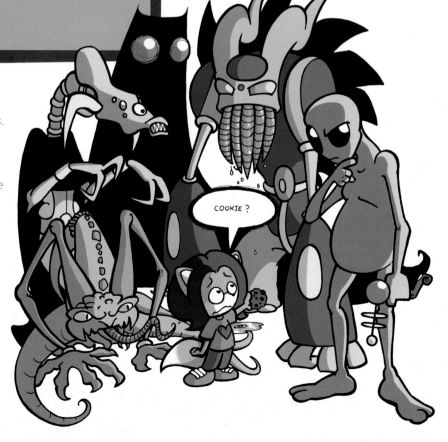

STYLE OF ARTWORK ◀ **73**

MANGA

A rebellious artist calling himself Hokusai was the first to use the word "Manga" over 200 years ago. Then, in 1947, Osuma Tezuka wrote and drew the first novel-length story *Shintakarajima (New Treasure Island)*. Mixing techniques from early cinema and the cartoon style of the West, Tezuka created a story that captured the attention of many Japanese readers. Tezuka's success inspired other artists to add to the Manga framework, and a new publishing phenomenon was born.

The big eyes are suggested by light and shade, and are often made to look even larger by the degree of light reflecting off them.

Hair is often disheveled, suggesting movement.

The mouth is typically small, and the chin tiny. Delicacy is a common theme in Japanese art—only villains and monsters have crude, ugly faces.

The nose is hinted at by a simple curved line and shadow.

DIVERSITY

Initially, Manga audiences ranged from pre- to late teens. However, as readers got older, Manga evolved along with them. Go Nagai's *Devilman* drew criticism for its violence and anti-heroic stance. Hayao Miyazaki originally published a Manga adaptation of *Puss in Boots*, but is most famous for his epic *Nausicaa and the Valley of the Wind*, with its strong ecological theme. Rumiko Takahashi has written romance, comedy, and horror.

VIOLENCE

Unless you're doing something as close to reality as possible, all the fights will be bone-crunchingly ugly, shootings gut-wrenching, and deaths more disturbingly vicious than any real-life psycho could manage.

🔺 NOW THIS WON'T HURT

A typical example of overplayed violence. In reality, no one could come out of this unscratched, even if he could fire accurately as he fell.

🔺 DON'T FORGET TO BREATHE

Another familiar scene—a smaller guy being pushed around by some mean man-mountain. Want to bet the big guy gets his comeuppance before the end of the book?

🔻 SQUASHED LIKE A BUG

A slightly surreal slice of violence. In previous panels, the robot appears to be normal-sized; only on this page do we see the reality. It's a darkly comic scene.

🔻 GO FOR YOUR GUN...

We're all familiar with the Western shoot-out. The use of guns is casual and expected; but in the scene below one of the protagonists is a woman. This is quite a switch.

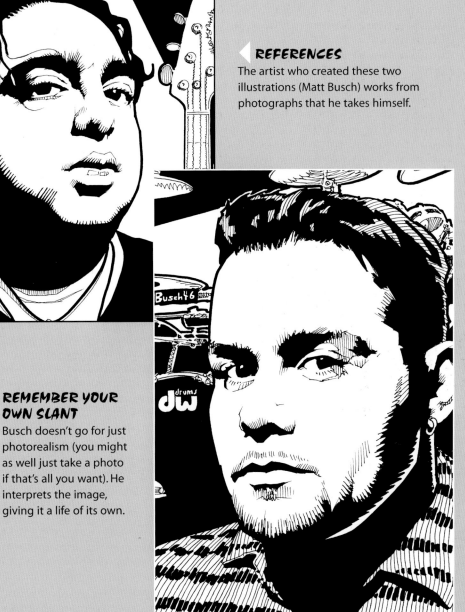

▷ **REFERENCES**
The artist who created these two illustrations (Matt Busch) works from photographs that he takes himself.

▽ CARTOON VIOLENCE

Some of the most violent scenes you'll ever see can be found in cartoons. The unreality takes the horror away and somehow makes it palatable. Below, the gunmen appear to be human-sized mushrooms.

REMEMBER YOUR OWN SLANT

Busch doesn't go for just photorealism (you might as well just take a photo if that's all you want). He interprets the image, giving it a life of its own.

PHOTOREALISM

Photorealism is a style in which the artist tries to make the artwork as realistic as possible. There are various ways of doing this.

The artists Alex Ross and P. Craig Russell both use live subjects in their artwork, but they approach the method in totally different ways. Alex Ross has a bunch of friends and relatives he paints as various characters such as Superman, Captain Marvel, and Wonder Woman. Picking his model to suit the character, and the use of natural light and paint give his artwork a photographic quality that is unique in graphic novel art. P. Craig Russell, on the other hand, sticks to traditional pencils and inking for his work. For the occasional large, close-up panel, he will use photographs (taken of a friend who doesn't mind posing for a succession of strange faces and poses) and draw from them.

It's important to note that you don't need to have your models standing in a field posing as you paint—photographs are fine. Take plenty, in all conditions, and you'll have a library of images to choose from.

TECHNIQUES AND MATERIALS

The earliest comic strips were black and white, simply because at the time, color printing was considered about as likely as color photography. Graphically, it was a black-and-white world (and destined to stay that way) until a cheap, three-color printing process was developed.

The first comic books were just reprints of newspaper strips. They were in color, of course, but they utilized a very basic coloring process that went for primaries every time. (Ever wondered why so many superheroes' costumes are blue and/or red?).

But the basis for all comic strips—just like their woodcut and acid-etched predecessors—is simple black-and-white artwork.

Varying the pressure you apply to a pencil creates different tones and textures.

Hard (H) pencils leave paler marks. Soft (B) pencils provide the black at the top. The more Bs, the softer the pencil.

PENCILS

Pencil can be combined with ink to create subtle shading and texturing.

Using soft pencil on coarse paper produces an effect similar to stippling.

Graphite pencil comes in different grades, fine for detail, and softer ones for rough areas of black.

Produce gaps by dabbing pencils with synthetic mounting putty that erases small areas.

Smudging a very soft pencil line can produce blending—a simply rendered gray tone effect.

▲ PENCILS
Due to the lack of cont[r]...
this image seems "flatte[r]...
than the inked version.

INKING

The most common and straightforward of all graphic art is pen and ink work.

You can use hatching and texturing to create shade. Different styles can suggest grain, curve, or direction.

Lines scratched into a dried ink surface reproduce woodcut effects.

Point stipple is laborious, but it can give a 3D effect when it's done well.

You can use pens of varying thicknesses, and even a piece of wood (bottom).

Sponging or using a textured board will give similar effects.

Inking with brushes gives a smoother line.

An ink wash over masking fluid can give a pleasing negative effect.

Masking with wax gives a negative effect, but wax is quite difficult to apply.

Dry brushing gives a fine texture and can be used to suggest grime.

COMPARING PENCILS AND INKS

Here is the same character done in both pencils and inks. Note that the penciled image is not only paler than the inked version, but is lacking in contrast overall.

◀ INKS

Note the use of solid black and hatching for both shading and the "color" of his clothing.

COLORED MEDIA

There is a variety of different media available to help you color your artwork. It used to be common to simply color graphics with inks, but recent improvements in reprographic technology has encouraged the use of better forms of coloring media. Paints, colored pens, and computer coloring can all be used today. Although there are few examples of fully painted books, and then only from the elite (Alex Ross again springs to mind), there's no reason not to experiment. You might even get to join the elite one day.

WATERCOLOR

Watercolor is a popular method of coloring. It dries quickly; but keep in mind, if you want to mask the original pencils, watercolor is not for you. Gouache and acrylics are both dense enough to cover any pencils (which means you'll need to do a rough color sketch in thinned paint first, building up from there to produce the completed artwork). But leaving the pencils visible isn't necessarily such a bad thing. If the rough pencil work shows through, it can give the artwork a feeling of urgency.

But remember, watercolor is never going to give you the same vibrant color as gouache or acrylic. It will always be somewhat muted.

Watercolors can be applied with a dry brush to give a textured finish.

Watercolors applied onto wet paper will flow and merge together.

ACRYLICS

Acrylic paint is remarkably versatile—it comes in tubes like oils, but can be diluted with simple distilled water. This means that a wide variety of styles are open to you. Straight from the tube, the paint can be applied just like oil paint—with brushes, palette knives, or any technique you like. By thinning it, you can achieve any consistency you want. It even imitates watercolor at its most extreme dilution. Once it's dry, acrylic paint is water-resistant, flexible, and tough.

Transparent acrylics can be run over one another. Compare the smooth finish with fiber-tipped pens in the panels opposite.

Scumble over a textured area by applying a thin opaque coat of paint to give a softer effect.

Sponging can give a texture that resembles sandstone.

Once paint has dried, opaque color can easily be applied on top to build layers.

Damp colors can be merged with a damp brush, losing all harsh edges.

Applying watercolor over masking fluid doesn't leave a clean edge, as ink does.

If you blot damp color with a paper towel, you get a swirling, fog-like texture.

Watercolors can be used as a transparent wash over finished work.

Thin paints can be run over a textured area to reduce contrast.

Running a transparent glaze over texture is one way of toning it down while introducing another color.

Acrylic paint can be mixed with a thickening agent and used like oil paints, giving a 3D effect.

Acrylic can be applied on a dry brush to "dirty up" an area.

FIBER-TIPPED PENS

Fiber-tipped pens have the advantage of being easy to use and quick to dry. They also come in a variety of thicknesses—from flat and broad, to bullet-tipped, to fine.

Ruled-line quality—broad, medium, and fine.

Fine points can be used for crosshatching. Using different colors suggests a variety of hues.

These are from an alcohol-based pen. Note how it forms lines where the ink has been laid down heavier—this is something to remember if you want a flat color base.

Transparent colors can be overlaid to give new colors and shades. Note that streaks are almost inevitable.

Felt-tips used on the back of paper to give a background, then hatched over on artwork side.

Fiber-tipped pens can be used for quick sketches and experimenting with colors.

Waterbased pens will naturally run because the ink takes longer to dry. If you want to merge colors use a wet brush.

GOUACHE

Gouache is a popular water-based paint that handles like oil—but like acrylics, it can be thinned down. It will even work in airbrushes. It is transparent when thinned down, so you can build up layers of color. This can give you a three-dimensional effect because reflected light will penetrate the various layers.

The thinned, transparent wash has had glaze run over it. The resulting mix of color is not smooth.

Opaque colors run up to one another, leaving a clear edge.

A dried layer has been scraped with a blade, revealing the base color in sharp contrast.

A semi-opaque white has been washed over the base color, softening it.

A wet semi-opaque layer has been sponged, allowing the base color to show through.

The airbrushed first coat has been graded with a layer of airbrushed white.

Applying opaque color over dried paint produces no mixing—each hue is separate.

Wet gouache can be easily blended, giving a soft color gradient with no edges.

CONTRASTING COLORING METHODS

The same little character is colored here using a variety of methods. You can see how watercolor and fiber-tipped pens are more transparent than either acrylics or gouache.

▶ **FIBER-TIPPED PE**

Like watercolor, a transparer media.

▼ **WATERCOLORS**

Totally transparent—the inking shows through the watercolor work.

▼ **ACRYLIC**

Very opaque unless diluted. Here it's used like oil paints.

GOUACHE

...re opaque than watercolor,
... still has some transparency
...en diluted with water.

COLLAGE

This technique involves assembling a picture from many different images, snipped from magazines, photographs, or wherever you might find them.

While it might be difficult—and a little trying for the reader—to create an entire book of collage, using collage for the occasional scene is often very effective, especially if it's attempting to reflect chaos. Cutting and pasting scenes from elsewhere in the book would add to that chaos—perhaps providing a visual hint of a character's incipient breakdown, or mental confusion.

These days, when just about everyone has a computer and scanner (or access to one, anyway), such manipulation is far easier than in the days of literally cutting and pasting.

PUTTING IT TOGETHER

You'll never stick to just one technique when you come to finishing your artwork. Blocks of color look boring and uninspired. This example has combined several techniques from the preceding pages. The figure's clothing shows gradation of color to indicate shadow and highlight. The background is spattered, and the upper half of the picture has the mottled look of dry brushing or sponging. The wings have been textured with stipple, and crosshatching has been applied to the arms of the costume to indicate some form of padding.

COMPUTER-GENERATED IMAGERY

Computer-generated imagery (or CGI) has recently been making great strides in movies, but its impact on graphic novels has also been significant.

There have been some digitally rendered graphic novels; once the new technology was firmly established, that was inevitable. Early ones were crude, and many artists thought the end product wasn't worth the time it took to create it. Besides, it quickly became clear that CGI's greatest contribution would be in moving images, so why use CGI for static ones?

Regarding software, it comes down to cost and processing power. Cheap CGI packages aren't worth their price tag; and even costly software won't be any good if it's run on a machine that doesn't have the required memory. Don't forget, a single, decent digital image can occupy megabytes of memory.

ILLUSTRATOR AND FREEHAND

These are the most popular illustration programs amo graphic designers and comic artists. They are used to cre what they call in the business *vector-based images* (drawings). Because no one in their right mind will try to cre line drawings with a mouse, you need a good graphics tab This is just a flat, pressure-sensitive pad that works with a pe

FLASH

Flash is a package originally designed for creating web sites. Illustrator and Freehand, it's vector-based, and the crisp artw that can be created on it has made it very popular. M illustrators and animators use it for both printed broadcast work.

◀ GRAPHICS TABLET

If a lot of your illustrations are created on a computer, graphics tablet and pen can help to prevent repetitive strain injury.

PHOTOSHOP

A widely used painting and image-editing program, Photoshop is particularly good for creating simple coloring effects and adjusting colors. Selected images are kept on separate "layers," so they can be worked on independently using the various tools that come with the package. The final image can be saved with the layers still separate. "Flattening" a file (compressing it all into one layer to save disk or drive space) removes the possibility of altering any single element later.

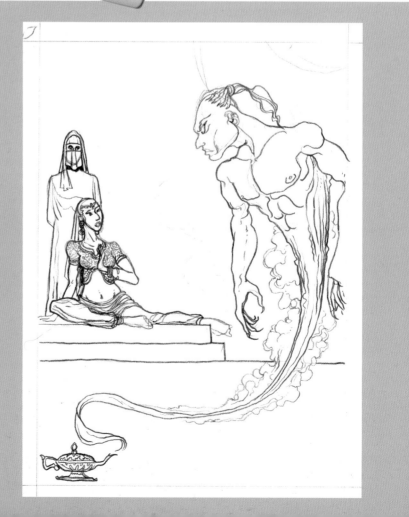

▶ FIRST SKETCH

This initial sketch contains the two hand-drawn elements that will later be combined for the final image.

POSER

This is a package used for designing 3D images. Starting with a simple figure, you can add skin, musculature, and change the shape of the head and torso however you wish. Using the tools supplied, you can position the figure and then dress it appropriately. There is even a palette to select the skin color and texture of the clothing and any other props you may wish to add.

▲ THE BEGINNING

This is the basic Poser wire frame model. It contains a "skeleton" that ensures that the figure moves correctly.

◀ TEXTURING

The palette is used for manipulating surfaces and textures. Clothing and props can be downloaded from copyright-free banks on the Internet.

▲ BEHIND YOU...!

The finished character, positioned, clothed, and beweaponed. He's also been joined by an ogre designed using the same technique.

BACKGROUND

image has been scanned in from ther source to act as background the genie and princess.

▶ FINAL IMAGE

The various layers together. To the right of the image is the "layers" palette, where each applied component is kept separate for ease of manipulation.

USE OF COLOR

The mix of colors (or palette) that you use will vary, depending on the genre or story that you're telling. You'll need to decide how much—or how little—of the available colors to use.

The greatest bulk of Manga is in black and white. Full color comics are rare—any color examples you'll come across will be from the top of the field. And those that are will have no specific palette—it's down to subject matter and artist's choice.

So what kinds of palette suit which genre? Obviously, horror tends to favor the primary colors— blood a rich red, darkness as black as you can make it—although sometimes a washed-out, dreamlike pastel design works well. Science fiction often cuts back to minimalist levels—Kubrick's *2001: A Space Odyssey* is a case in point. On board the ship, virtually everything is white, with only the crew's uniforms and spacesuits (and the food, interestingly) providing color. Even the closing scenes featuring the rapidly aging Dave Bowman are given a sterile sheen through the use of white light.

FANTASY COLORS

With fantasy, you're in the realm of the ultra-real. Color be vibrant, enhancing the surreal qualities of the story. Rodionoff's *Dark Fantasy Lovecraft* (D. C./Vertigo) examples of how changing palettes emphasizes chang mood and reality. The colors of Enrique Breccia's pai artwork are muted during the young Lovecraft's childhood, startling at the start of his romance with S and dreamlike when he visits nightmarish Arkham.

WARM AND COOL COLORS

All colors can be categorized as either "warm" or "cold." see it instantly. Yellow and red are warm; blue and gra cold. Choosing whether to color a scene with warm or colors gives it an instant bias. An indoor scene th colored with predominantly pale blues will feel deta and remote—literally, cool. The same scene in reds yellows will be more immediate. Red can also symb danger: as in red alerts or fires—especially those liquid that explode from volcanoes, or the occasional visit to

Green can either be warm, as in the color of leaves forests, or spooky. Radar screens give off an unearthly g that taints the operator's face. Combine that with the coming from below the face, and you've got an intir slightly off-kilter scene.

THE COLOR WHEEL

This simple device arranges the three primary colors (red, yellow, and blue) in sequence with the secondary colors (orange, green, and violet), which are created by mixing the primary pairs. Colors that oppose each other on the color wheel—such as red and green—are called complementary colors. These provide maximum contrast because they are, quite literally, opposites. Colors adjacent to one another blend well.

Along with complementary contrasts, warm and cold colors also contrast—orange and violet, for instance.

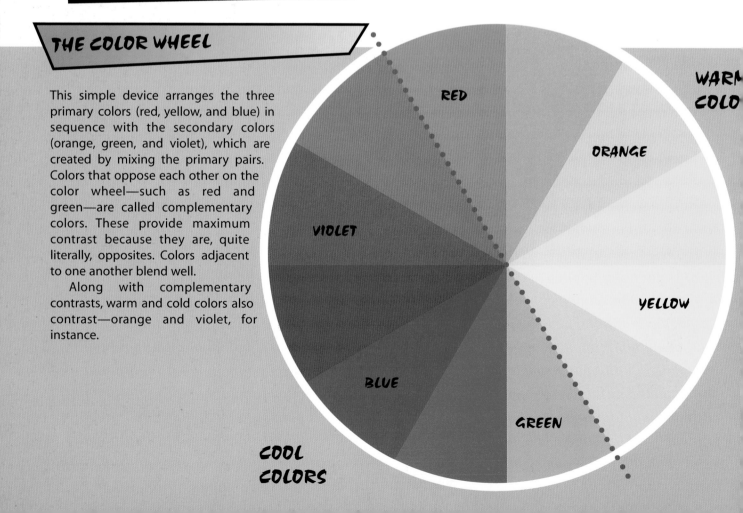

▼ SELECTING COLORS

You'll often see, when looking at colored pages, that some colors seem to be coming toward you while others are backing off. To make something appear to advance, warm colors (like red and orange) are best. Cooler colors, like blues and greens, seem to recede when put against red.

ADVANCE ADVANCE

RECEDE RECEDE

▼ TONAL CONTRASTS

This graphic demonstrates tonal variation applied to different colors (along the vertical axis). Each color gradation will contrast with the tones both above and below it. You can create harmonies between colors of the same tonal quality and saturation (along the horizontal axis).

Light

Dark

COLOR IN PRINT

CMYK

In the four-color process, the full-color artwork is electronically separated into an image composed of cyan (C), magenta (M), yellow (Y), and black (K) dots. With this method, millions of hues become available.

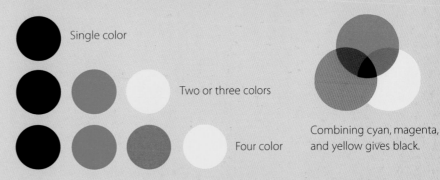

Single color

Two or three colors

Four color

Combining cyan, magenta, and yellow gives black.

RGB

Red, green, and blue are the primary transmitted colors that are the backbone of the seven-color spectrum. Their use in the printing process is negligible.

Combining red, green, and blue gives white.

LAYING COLOR TINTS

A tint can be a single color, or a combination of inks. Spot color (black and one or two other colors) is cheaper than the four-color process, but provides a much more limited range of tints.

2 color

3 color

4 color

3 color

4 color

DRAWING FROM A SCRIPT

It's pretty obvious that you can't jump right in and start drawing the book as soon as the script drops on your doorstep. You're going to have to get a feel for the work, sketch a while until you're happy with the way things are going. Take a few dry runs at the imagery until you're confident you know how everything will fit together.

Let's face it—the author knows everything there is to know about the story—it's his or her baby. But you're coming into it cold. It'll take a while until you know this world, and these people, as well as their creator— do your best to use that time productively.

▶ SEE ALSO
Briefing an artist, p.60

PRELIMINARY SKETCHES

The writer's script will tell you how many panels sh[ould] be on each page, but it won't tell you how to pos[ition] them. It's the artist's job to figure out how to best pre[sent] each page so that the story is well told, and empha[sis] put in just the right places.

The writer will surely have sent you chara[cter] descriptions in advance; but unless each description [is so] brilliantly conceived that the character leaps off the p[age] and into your head, you'll probably need at least a co[uple] of attempts before you're happy.

Once you're satisfied with how the characters l[ook,] you'll need to lay out each page by drawing each pa[nel.] The script might demand that a character is in so[me] particular position, but you might often find it works [better] if they're placed somewhere else.

Don't forget, each panel isn't a picture independen[t of] all the others—they all have to interact to tell the s[tory.] You're not going to find that rhythm or flow right aw[ay.]

GROTESQUERIE

Here is a whole pantheon of demons. On this page, it's clear that whatever dimension these things are from, family traits are rare. Every creature is different from the rest. This makes for some great visual fun—but it can be very taxing on an artist's imagination.

Another demonic face, slightly closer up. It shares the three-eyed trait, but the teeth are smaller—like needles—and the face is a totally different shape.

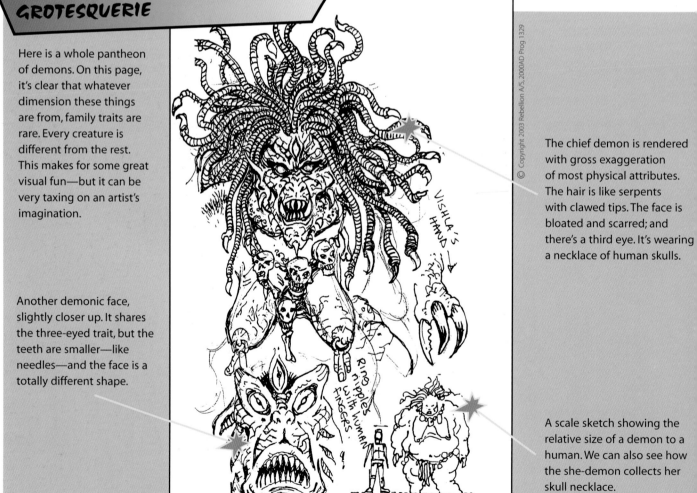

The chief demon is rendered with gross exaggeration of most physical attributes. The hair is like serpents with clawed tips. The face is bloated and scarred; and there's a third eye. It's wearing a necklace of human skulls.

A scale sketch showing the relative size of a demon to a human. We can also see how the she-demon collects her skull necklace.

MAIN CHARACTER SHEET

A close up on the creature's leg. Smaller details such as limbs and heads are often included alongside the sketch of the whole animal to flesh it out. This can draw attention to areas that may very well feature in the story.

A detail of the sort of creature used for transport.

The title character. This sketch is rendered in a great deal of detail, showing the hairstyle, clothing, and even the designs sewn or printed on the robes. A detailed sketch like this is almost of high enough quality to be part of the finished artwork (as some of these images actually were).

Detail of the character's hand. If the character has something noteworthy about his or her hands or feet —or anything that will factor into the story—a detail of this needs to be included in the sketch.

The villain's lair, showing the bones and skulls motif that will be reflected in his costume.

NORT'S RIDER BEAST →

NORT'S SERVANT.

SKRIXLAN NORT.

NORT HAND

SOR'S DOMAIN

HEAD OF NORT RIDER BEA

DEMON

DEMON

ZOMBIE

WAND

MAGIC SYMBOL.

SKETCHES JON HAWARD

COSTUME AND APPEARANCE

The first sketch of the female lead character was abandoned, as the artist wasn't happy with it.

Second attempt. The writer wanted the girl to be sexier, so she was redrawn with a little more cleavage, chains around the shoulders, and jewelry pointing straight down her décolletage. It is a fact that women in fantasy will always be wearing very little, even in cold climates.

Detail of the girl's costume. In this kind of story, even a princess has to dress like a slave girl.

Both sketches of the girl are from front, but it's important to sho how her hair han down at the back it's part of the overall look.

The king. A benign-looking, chubby character. His costume exaggerates his build, making him look slightly ridiculous (note the crown).

The villain. In contrast to the king, he is lean to the point of gauntness. His hair is lank, and again there is the skulls and bones motif in his costume, his staff, and even his hair. This deliberately echoes the design of his palace and creates an instant resonance that the reader can appreciate.

The king's palace. This was based on a building in Istanbul, because the writer wanted a Turkish feel to the architecture. It demonstrates that even in something like fantasy, the artist will need to do research, even if it's just architectural styles.

...CILING

...v polished the final pencils are depends on how you work ...with your inker (if you're not doing it yourself). Loose pencils ...e the inker space to put his or her own polish. If you have a ...e collaboration with your inker (think of Klaus Janson and ...k Miller on *Dark Knight Returns*), you'll soon figure out how ...to work together.

...f you're working with a main publisher, they'll supply you ... artboards of their own. The board will be much larger than ... printed page; everything is photo-reduced in graphics ...lishing. So when you're drawing, don't go for masses of small, ...cate detail—it will disappear during reproduction.

INKING

A page of penciled artwork can be changed, but a page with ink cannot. Be sure you're totally satisfied with the artwork before you start inking.

The purpose of inking a page is to make it more visible to the scanner. When graphic novels first started, photographic films and emulsions weren't as sensitive as they are today. They needed a good, black image to capture all the details. It is possible now to scan in pencils and work from a high-quality digital image, but the printed image may not be as good.

Another reason for inking is to add depth and greater contrast to the pencils. (Some artists deliberately use pencils for gray-scaling after inking, instead of ink washes.)

Ways of getting all that ink onto the page vary with the artist. Some prefer brushes (take a look at some completed artwork— the pages where lines thicken and taper smoothly is brushwork), others work with pens (often fussy, detailed work), and others use whatever is at hand (examples here).

© Copyright 2003 Rebellion A/S, 2000AD Prog 1329

DETAIL

These two enlarged examples of one panel—in pencils and final inks—are a good way to compare the final product with a work in hand. The most obvious point is that the inked version has far more detail than the penciled. The first version is obviously just trying things out as far as checking positioning and placing of figures. The lines are also much finer in the finished product—the initial pencils can be done crudely, with a soft, black pencil that will be rubbed out later.

PUBLISHER'S ARTBOARDS

Comic artboards are thicker than sheets of art paper—but not indestructible. They're larger than the printed page, since all comic art is done oversize to visibly reduce errors—so when you're drawing, don't go in for small, intricate details that will disappear when the page is scanned and reduced. A photo-blue border proportional to the finished comic page marks out the drawing area. And there's always provision (outside this border) for notes— name, title, page number, etc.

COMPARE AND CONTRAST

Here are both pages in full—initial pencils and finished inks prior to coloring. Although we've looked at one panel in detail on the previous page, it's still instructive to compare the rest.

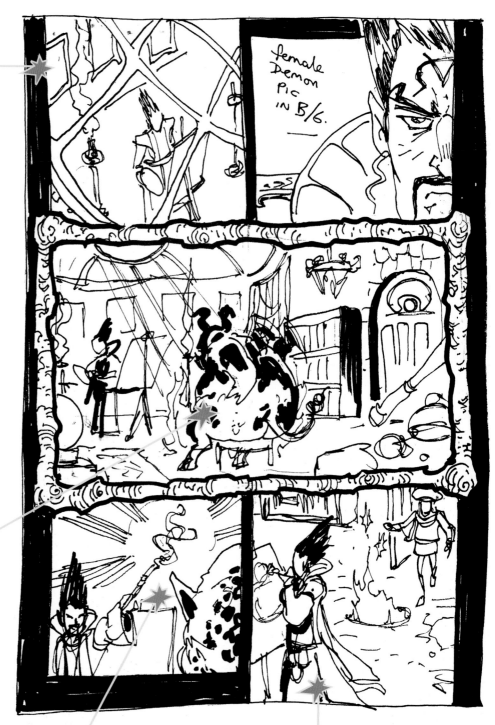

Despite the extra detail in the finished inked version—brickwork, paintings, etc.—it's clear from the rough that the picture was already quite firmly in mind. The window is another homage to Dr. Strange, which is the familiar skylight in his New York home.

The demon is even more of a blob—nothing more than a black and white shape (like an overweight cow). Again, it has more to do with shape and position.

At this stage, the wand that he's waving here looks more like a smoldering branch—something to address before the finished product.

The figure is crudely depicted because the artist is more concerned with scale and where to place him than detail.

You'll note that the artist has left room in all the panels for speech and narrative. This has to be kept in mind at all times—not only because the panel can look cramped, but the letterer might have to place bubbles or caption panels over a vital part of the picture.

The painting in the background of the finished panel is based on the she-demon found in the character sketches. The close-up of Nort changes little from one version to another.

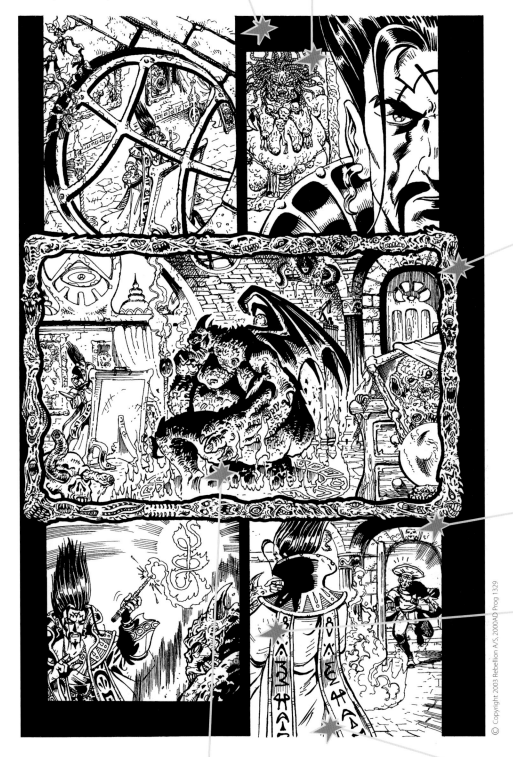

The finished product has a grimmer feel to it than the original. Note the rough bookshelves, chandelier, and sunlight coming through the window. The final ink-up is lit by the flames of the demon, and the stone and brick walls are much darker in tone. However, the fancy border has survived.

The perspective has altered drastically from the initial sketch, which was looking down on Nort, almost echoing the first panel. The inked version has brought us down to ground level, however, and we're looking over Nort's shoulder as his servant enters.

The easel that had been in the background of the initial sketch is now gone. Clearly, the artist thought it made the frame too cluttered, or detracted from the characters. Often, especially in a small panel, a blank background is best.

The demon is similarly detailed. The blob is gone and has been replaced by a hulking menace. Note that the horns have changed shape completely since the initial pencils.

Here we can see the detail of the character. All of the patterns on the robe are in place, the figure gestures are included (a tribute to Ditko's Dr. Strange), and the wand is now describing a complex spell in the air.

COLORING

Coloring is the final stage before the repro process. The colorist receives photocopies of the inked artwork, which he or she colors using watercolor dyes, color markers, or a mix of the two. These guides (or specs) are for indication only and will never actually see print, but it's best to try and paint them as close to how you want the finished art to look. When the page is completely painted it then needs to be coded. You can either use percentages or the Pantone color guide. Using percentages of Yellow (Y), Blue (B), and Red (R), you can make any color in the spectrum. For example, Y100 R100 indicates 100% Yellow and 100% Red, and means for color separation the marked area will be overprinted with both solid yellow and red. Pantone is a system universally understood by printers and computer systems, with millions of hues, each allotted a code (for instance, 16-1359 Orange Peel).

Now, of course, most of this problem is solved by computer. The inked page is scanned in and the colorist fills in those white spaces with virtual ink from whatever graphics package he or she prefers (Photoshop is one of the better-known packages). This means that—coupled with vastly superior printing—the range and subtlety of coloring has greatly increased. Where once the colorist had to be content with plain blocks of primary and secondary colors, now there is scope for gradations of color. Flesh tones aren't just a few red pixels against a white background. Now the colorist can blend in all tones, like adding shadows that the inker has left out and highlighting brows and noses. On the minus side, it is too easy to get carried away with all the extras—things like lens flare, starbursts, texturing, and blurring. Many of the effects are valid, but end up losing all their effectiveness through overuse.

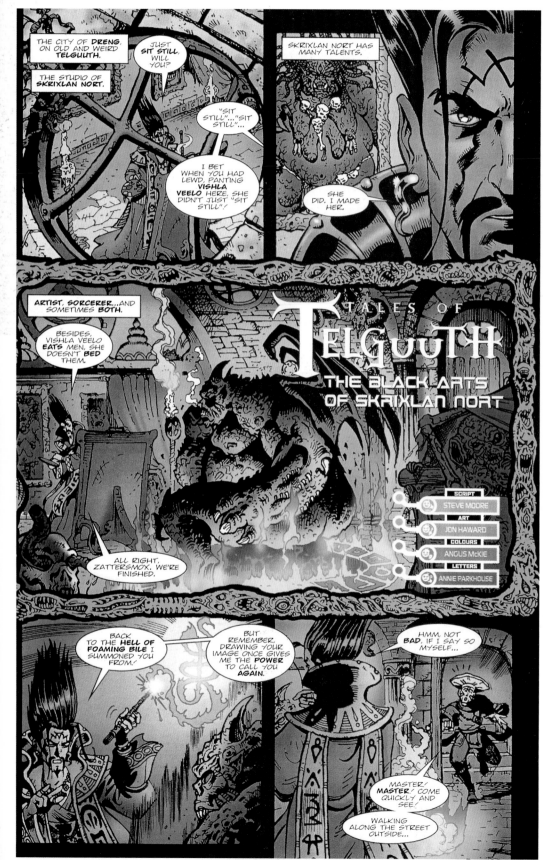

CREDITS

This is the credits panel. Note: this is from a British title—*2000AD*—which makes its presence unusual, since graphic novels in the U.K. rarely credit the creative team. But spot the difference from an American book—no splash panel, not even a one-page spread. All contained in one panel.

COLOR AND SHADING

Sometimes you will be called upon to draw something you won't find in reference books, and you'll need to use your imagination to get the color and shading right.

SKETCHING
The talon is roughly sketched, using circles and oblongs to suggest bones.

FINISHING OFF
Inked and colored, the talon now looks three-dimensional, thanks to shading tones. Note the suggestion of scales on the forearm.

BROUGHT TO LIFE
Although purely imaginary, the clever use of coloring brings the dragon to life. Dramatic lighting from the flames adds that final touch of menace.

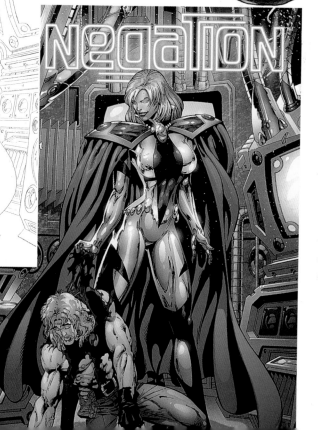

▲ THE PENCILED COVER
The penciled art looks off-center, due to the large areas of intrusive background designed to leave room for the title. In this example, there also needs to be a space for the publisher's logo and price, and even a creator credit.

◀ THE FINISHED ARTICLE
You'll note the artist left room for bubbles, titles, and credits. The subtle shading and highlights that the modern coloring process is capable of brings the art alive and adds depth.

ALL ABOUT LAYOUT

When a script has been written, it is up to the artist to realize it visually. The layout can go through many rough sketches before the final style is chosen, and even then—if the artist is working closely with the writer—the author might want changes. As with writing, illustrating is a fluid and dynamic process (of course, if you are illustrating your own work, you only have yourself to blame!).

There are many ways to illustrate a graphic novel. The traditional way utilizes five to seven panels per page—clearly lined with gutters between panels—telling the story in a more or less linear manner. But there are plenty of other methods, as the medium of the graphic novel offers a great deal of freedom to experiment with form and expression.

Combining artwork with text is an excellent device if you are looking to achieve a classic storybook look, used to great effect in Neil Gaiman's *Miracleman* collection. Text and artwork can be combined to a greater or lesser degree; while the text reveals one dimension of the story, the artwork—using more traditional speech bubbles—can run a parallel storyline.

▶ **FIRST LAYOUT**
This is a traditional layout with no overlaps or breaking out of panels. Set out in a very simple way, it is just to get a feel for the pacing of the story and to see how each of the panels fit into place.

▶ **SECOND LAYOUT**
You can begin to experiment a little and make the arrangement of panels look more interesting. Also start to work out the "shots" of faces and how to "cut" from panel to panel.

▶ **THIRD LAYOUT**
This is the same content as the previous example, but with a different layout. Never be afraid re-sketch a layout until you are completely satisfied.

DEVELOPING PAGE LAYOUTS

The artist has already begun to experiment with thumbnail layouts on the actual pages of the script.

▶ **THE SCRIPT**
When you first view the script, attempt to break each final, printed page into panels. Note the rough sketches and numbers—these are keys to help organize the panels.

1.1.4
- I must have become so desperately isolated to be able to delude myself like this...such foolishness.
So I turned to walk away and close the door on that memory...

And he walks straight into Nish

1.2
- are you lost ? You seem to be looking for something.
- I'm looking for ... a grave.
- that sounds serious ... who's grave ?
- I don't know ... it's a long story ... it happened in 1857...
- ahh...1857...you should meet my Uncle...he knows a lot about *that*...maybe he can help you...what's your name ?
- Tyler...whats yours
- Nish
- Thats a beautiful name ...

1
2
3
4
5
6
7

The artist has numbered the passages of dialogue, and is already planning which panels the speech balloons are going to be grouped within.

Vyram: October 2002

FOURTH LAYOUT

When you are happy with the initial design, you can begin to add flourishes such as overlaps and panels floating up over larger background panels.

FINAL LAYOUT

Full attention should now be focused on the composition of figures and faces. You should make a final check on the pacing and flow, and, most importantly, check that the story makes sense.

▶ FINISHED PAGE

This uses a mixture of narrative (top left-hand corner—bold white type), speech bubbles, and panel overlaps. Note in the bottom right-hand corner a last-minute change from the final layout—the introduction of a layered panel.

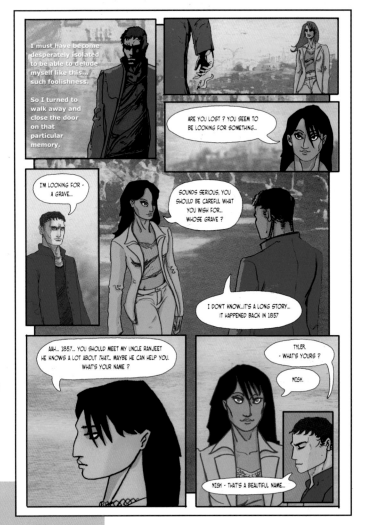

ORDERING PANELS

In the West, we are conditioned to read from left to right, which means we approach comic art in exactly the same way: we expect panels to go left to right, back and forth down the page. But sometimes things go astray—maybe the artist gets too clever—and the eye starts to get confused.

COUNTERCLOCKWISE

In this first example, the eye automatically jumps from frame 1 to frame 3—because it's immediately to the right. In fact the story goes to the frame immediately below. If you're stuck with this arrangement, you'll have to think of some way to direct the eye. Not so long ago, publishers would have used arrows.

FLOATING ADRIFT

Another confusing example. Two smaller frames are floated over a one-page illustration. Again, the eye wants to go for the frame closer to the top right-hand corner—even though the bottom left is next. In a case like this, it might be possible to use speech balloons to pull the eye in the right direction.

OVER TO YOU

▶▶ Experiment with your own layout designs. Imagine a scene and then see how many different ways you can visualize it. Perhaps it can be seen from both characters' points of view. How best could you achieve this? Maybe it could be told through a series of flashbacks.

▶▶ Learn from others. Observe how other writers and artists approach scenes. With the aid of thumbnails, experiment with your own approach. Don't be afraid to copy at first—it's how everyone starts.

CHOOSING FRAME SIZES

The actual size of the frame—in relation to its content—is an important consideration. If a huge, one-page frame dwarfs an object, it's going to look lost and small. If that's what you want to evoke, then fine, but if it's something you want to draw the reader's attention to, you've failed. Drawing the same object, the same size, but in a much smaller frame will instantly draw attention to it. It's all about perception. A simple optical illusion can make something seem either bigger or smaller than it really is. Even a tiny diamond, if drawn crammed up against the edges of the frame, will appear to be huge. Actually putting the object outside the frame—making the frame smaller than the object—will really make it stand out. (In this case—literally).

But like everything else, it has to be done properly, or you get the wrong effect.

THE STORYLINE

A couple of masked robbers enter a jewelry store. They're dressed in black. Brandishing shotguns, they scare the handful of customers into one corner of the room, then make for the central display.

A shop assistant reaches for the alarm button. One of the robbers sees what she's doing and swings a gun in her direction.

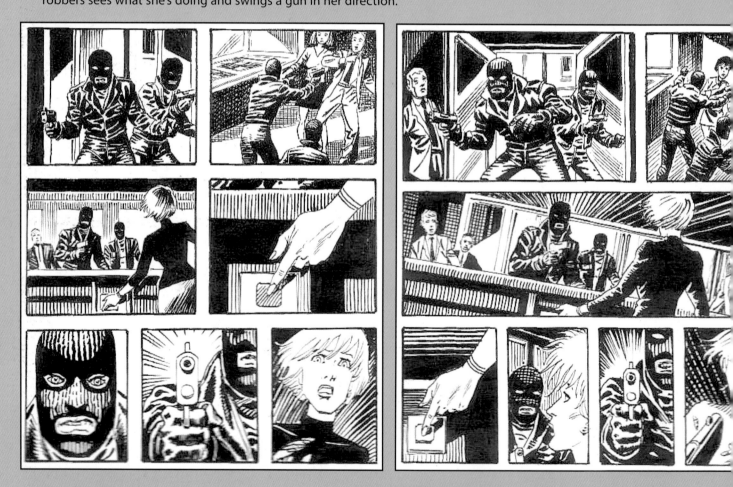

THE WRONG WAY

The panels are a similar size, and there's no feeling of movement or importance. What's more, there's no sense of focus; so readers will wonder just what they're supposed to be looking at. Where's the major action?

THE RIGHT WAY

The way in which the size of these panels changes is a way of cranking up tension. The sequence begins with regular panels that don't concentrate on anything specific, moves to the pivotal center panel, where the assistant is about to push the button, and finishes with rapid-fire panels.

CHOOSING WHICH INSTANT TO FRAME

In the example below, the same moment is shown two different ways. The simple tale is of a boy sitting on a riverbank, fishing. He gets a bite, and after a struggle lands an old boot. His line snaps and the boot splashes back in the river.

In the first example, the boy is so far away that there is no feeling of intimacy for readers. With each incident, we find it hard to care, because we've not been invited in; the boy's just somebody in the distance.

In the second version, we are drawn slowly into the chain of events. The long shot in the first panel sets the scene. We move closer as something snags the line, and closer still when the boot is caught, and the line breaks. As the boot sinks, the boy's posture and body language of the boy indicate that he is upset.

THE WRONG WAY

1 The boy on the riverbank, line in water. Long-shot.

2 Pulling up the boot. Middle distance.

3 The line snapping. Middle distance.

THE RIGHT WAY

1 The boy in the riverbank in long-shot.

2 The boy close (not too close). His rod is bending as something snags the line. His face is lit up, expectant.

3 Close-up of an old boot coming out of the water.

4 The line snapping, dropping the boot back in the water.

5 The boy standing in middle distance, looking desolated. His body is sagging with disappointment.

CLASSIC LAYOUT DEVICES

Most strips break down into a regular format of 5–7 panels per page. But how one lays those panels out varies tremendously. Depending on the impact one wants to create, there are several different styles of layout.

The way in which the frames progress is as much a part of the storytelling as the written narrative. The frames carry the eye along, guiding the reader through the story. This means that the layout—no matter how unorthodox—must not be confusing. An artistically pleasing design is all very well—but of no use if the reader is sent off in the wrong direction. It's also a disservice to the writer.

The conventional layout has clean lines around each panel and a space between (known as the gutter). Laid out in a linear (and usually chronological) manner, the size and placing of each panel normally depends on how much detail one needs to pack in (one can't squeeze a legion of characters into a small space!), and the impact it needs to convey (a large frame with little in it can create a sense of isolation, or alienation—a tiny frame can be used to show a single detail).

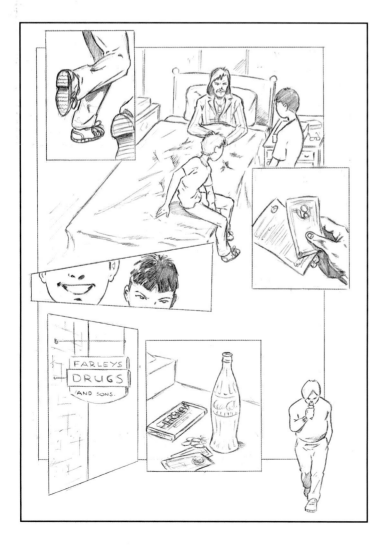

THE LANGUAGE OF PANELS

Apart from the traditional panels—side by side and observing orders—there are other, more adventurous sty These are multiple layer, break-up, overlapping, and frameless illustrate these, we have the same tale illustrated four ways— and Will Whitely visiting their grandpa and wasting the mo for his medication on themselves.

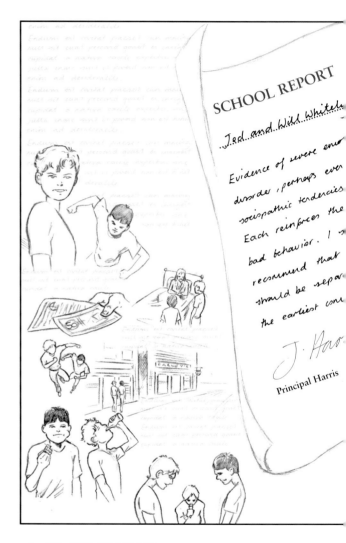

▲ MULTIPLE LAYER

Here, Jed's own version comes first as simple narrative. The visuals come next, floating over his words, and may not always agree with them. But overlying everything is a school report on the brothers, adding an intriguing gloss to the story.

◀ BREAK-UP

The story is shown as a series of broken-up images overlying the central one of a sick man in bed. The main events that follow—money, drugstore, soda, and candy— are given a sense of immediacy, springing simultaneously from the central image.

▶ OVERLAPPING

Here, Jed is the constant. He overlaps the entire sequence of events, as though he's orchestrating them. In the multiple-layer version, his words provided the spine—this time it's his actual presence.

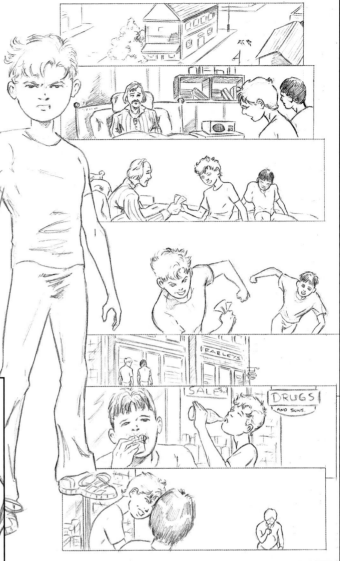

◀ FRAMELESS

This version is a more free-form method. Without the constraints of frames, the whole story becomes one event—from the moment the brothers leave school to the visit with their grandpa, to the trip to the drugstore. It flows effortlessly across the page.

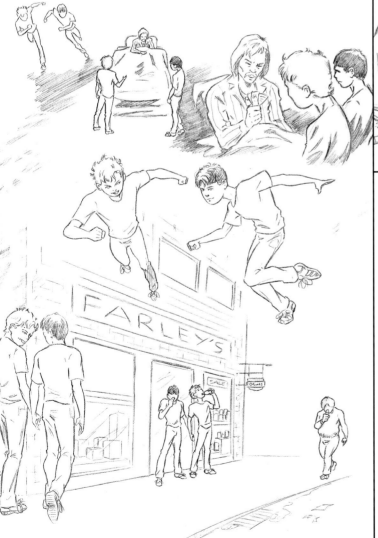

▶▶ SEE ALSO
Panels, p.22

ALL ABOUT FRAMING

The size and positioning of each frame is just as important as its contents. Frames may be placed in eccentric positions to draw attention, or simply drawn differently from the others. A huge panel, following a series of identically sized ones, will be a natural climax to the page. But remember that the decorative or displaced frames are there for a purpose—if you're catching the reader's eye, they'll want to know why.

The contents can also be used for similar effect. Suddenly changing the style of artwork, or the medium in which it is presented, not only draws attention, but can be a way of altering the mood. Abrupt changes will shock or alarm the reader, so again, choose these instances wisely.

▶▶ **SEE ALSO**
Framing devices, p.26

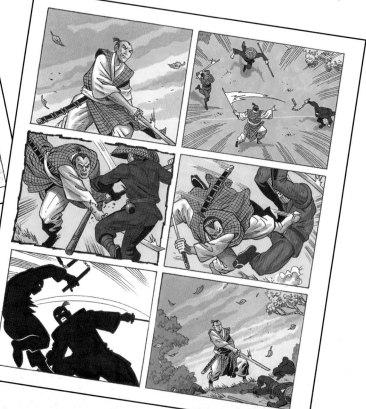

▲ Blowing up a sing detail is an easy way to the reader's eye.

▲ A single color frame in a black-and-white spread really tends to stand out. The abrupt splash of color is almost surreal in its intrusiveness.

▶ One black-and-white frame in a color strip can be just as intense, but in a more somber way.

▶ Tilting the frame at a different angle suggests that particular scene is out of sync with the rest.

▲ Having one frame much larger than the others almost suggests that it's more important than the rest.

NOVELTY FRAMES

35MM FILM
Whenever you want to suggest we're looking at an actual film still, or suggest that someone in the frame is secretly being filmed.

TV SCREEN
Several artists have used anchormen and women in TV-shaped panels to fill in details of the plot as news headlines.

COMPUTER SCREEN
You can use this to show text scrolling across the screen—or as an actual picture. Imagine a PhotoShop graphic fading to an actual moving scene in the next panel.

PAINTINGS
Adding fancy Baroque frames to panels is fun, and can be used for many reasons. They work well in fantasy settings, obviously; and equally in Gothic ones—where decadence drips from everything.

BILLBOARDS
Even advertisements can figure into your story—the girl advertising cigarettes suddenly starts talking to the hero, or she becomes someone he knows.

THINKING LIKE A MOVIE DIRECTOR

Both movies and graphic novels use similar terminology for various images (long shots, tracking shots, middle distance, etc.), and both mediums use them in pretty much the same way. The scripts normally have simple notes like "Jim in close-up. Jane in middle distance." The details are up to you.

An establishing shot probably won't be called that—generally, the writer will simply say something like "new scene"—but it's obvious that's what you'll be drawing. Close-ups and long shots are there to zoom in at moments of tension, or back off mostly for detailed shots.

Panoramic and middle-distance shots are, again, for detail shots—getting a lot in without crowding the picture. Panning and tracking shots are difficult to do in a static medium, but can be hinted at. In *The Exiles* from Neil Gaiman's *Sandman: The Wake*, Jon J. Muth's artwork contains some very effective uses of pans and slow zooms.

Filmmaking terminology is used throughout graphic novel scripting. Long shots, close-ups, and panoramic shots are just a few of the relevant terms.

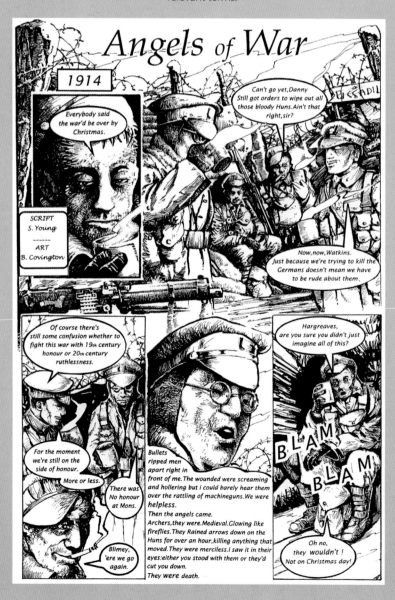

▲ CLOSE-UP

A reaction shot, generally used to show the emotions on a character's face. Wider-angle shots frame this panel, so the impact is much greater. The angry, snarling face leaps out at the reader.

◀ ESTABLISHING SHOT

This is the opening panel of a new scene, especially if you're introducing new characters or situations. Here, the first panel is a close-up, floated over a larger one (it's the bigger panel that interests us). Immediately, the reader can see that the story is set in the mud-filled trenches of World War I.

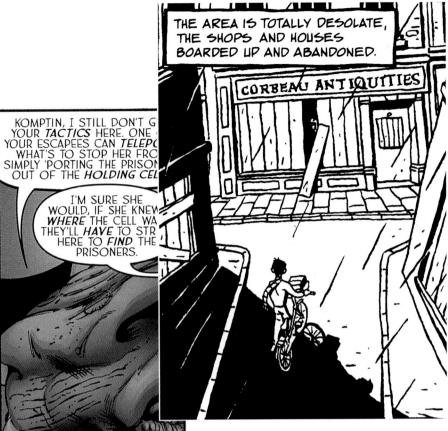

THE AREA IS TOTALLY DESOLATE, THE SHOPS AND HOUSES BOARDED UP AND ABANDONED.

CORBEAU ANTIQUITIES

▼▶ EXTREME CLOSE-UP

This is not something you want to use too often. This example shows good usage of it pretty clearly. We already have two consecutive close-ups. Now, the only way to create an impact is to go in even closer, concentrating on a mouth or eyes. As you can see, the end result can sometimes be a bit grotesque.

KOMPTIN, I STILL DON'T G___ YOUR *TACTICS* HERE. ONE ___ YOUR ESCAPEES CAN *TELEPO___* WHAT'S TO STOP HER FRO___ SIMPLY 'PORTING THE PRISON___ OUT OF THE *HOLDING CEL___*

I'M SURE SHE WOULD, IF SHE KNEW *WHERE* THE CELL WA___ THEY'LL *HAVE* TO STR___ HERE TO *FIND* THE PRISONERS.

AND WHAT THEN? WE'VE ALSO SEEN THEM PROJECT *FORCE-FIELDS* --

___U'RE *CERTAIN* ___HEY'LL COME?

IF I LEARNED ONE THING W___ HAD THEM IN CUSTODY, IT'S ___ HUMANS ARE *RECKLES___* *SENTIMENTAL*. THEY'LL MOUNT ___ HOPELESS *RESCUE* AT___ RATHER THAN WATCH ___ COMRADES *DIE*.

▲ LONG SHOT

The opposite of a close-up. This is useful when you're not interested in the full-on emotion of a character, but instead how they fit into the landscape. In this image the characters are small against a desolate, abandoned backdrop. The boarded shops are eloquent enough, but the smallness of figures increases the feeling of isolation.

MIDDLE DISTANCE

The dinosaur in this picture is in the middle distance. Although the main character is in the foreground of the picture, it's the creature that's the focus of the panel. Even though it is further away, due to its size it still fills the frame. Middle distance shots can thus be used to get a number of large objects in view, or more simply, to create perspective.

PANORAMIC SHOT

The only way to get a real impression of sheer size is to use a panoramic shot—just like a photographer would use a wide-angle lens. Here, the characters in the foreground are there just to supply story continuity; as above, the real focus is the mass of rocks in the background.

PANNING

The picture at left tries one way to suggest a panning shot. By having one character split between two panels, and moving his head back and forth between the other characters as they speak, it creates the illusion of movement. We have panned to the right, and his head has followed the movement.

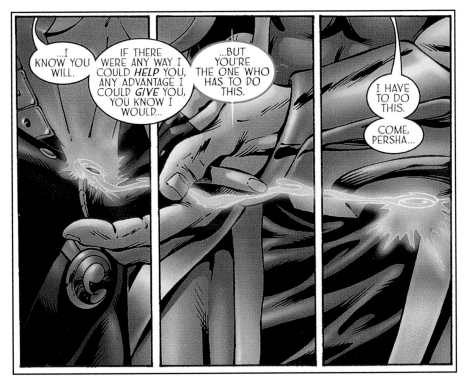

TRACKING SHOTS

You can't move in comic strips, obviously, but you can hint at it. Camera movement can be imitated over a series of panels. Imagine your establishing shot is an apartment building; over the following panels you can zoom in—on a particular window, for instance—while a conversation is taking place off-screen (or off-panel, pick your own terminology). Because we don't have a real camera, and physical constraints don't matter in comics, we can go straight through the window, into the apartment, and meet the characters who are talking. In a movie, such a shot would be technically challenging (though not impossible).

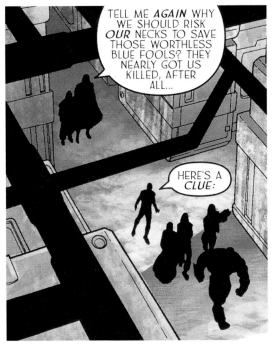

TOP HAT (OR T. H.) SHOT

This is one used in TV and movies that allows you to look down on the cast from above. You don't have to worry about what it's called—just saying "looking down from fifty feet…" or something similar will probably do.

OVER TO YOU

Take a specific scene—it doesn't have to be anything complicated; a few people in a bar, with other patrons walking in and out would do. Then consider how you would illustrate it, using the types of shot we've mentioned.

▶▶ *Where would you begin? What establishing shot would you use?*

▶▶ *Would you use a panoramic shot to include the whole bar, or more intimate close-ups?*

▶▶ *As a new character enters, how would you show him or her—as an aside in the distance, or a foreground shot? Consider how important they are in the scene to help you decide.*

▶▶ *Under what circumstances might you use an extreme close-up in this scene?*

▶▶ *How would you end it?*

LIGHTING

Lighting can play a tremendous role in setting the scene—even more so in a black-and-white strip than a color one. Obviously, the dark is used to crank up tension (who knows what's lurking out there in the shadows?). You may have seen a few examples of the old film noir movies of the late 1940s and 50s. They made great use of the play of light and shadow (usually because the budget was too low for decent scenery!). The striped shadow of window blinds cast on an office wall is an image hard-wired in all of us by now. And it goes without saying that shadow itself can be used to cast disturbing and misleading shapes. Two of the best practitioners in the use of lighting are the veteran Alex Toth, who, aside from his many strips, did character design for Hanna-Barbera cartoons like *Scooby-Doo* and *Space Ghost*, and Mike Mignola of *Hellboy* fame (now working in movie design on *Hellboy* and *Blade II*).

And to bring us back to rain again, don't forget the way streetlights can reflect off of damp sidewalks and tarmac, and how it sparkles as it's caught in headlights.

in circles

▲ APPROACHING LIGHTS

In the dark, even a distant light can pick up small details. But if it's moving, it will eventually drown out the night. Remember, behind that dazzling light, anything might lurk.

▲ REFRACTED LIGHT AND SHADOW

Rain on a window can create strange patterns as it refracts and twists the light. When those patterns are thrown across a room or a face, it can be very evocative.

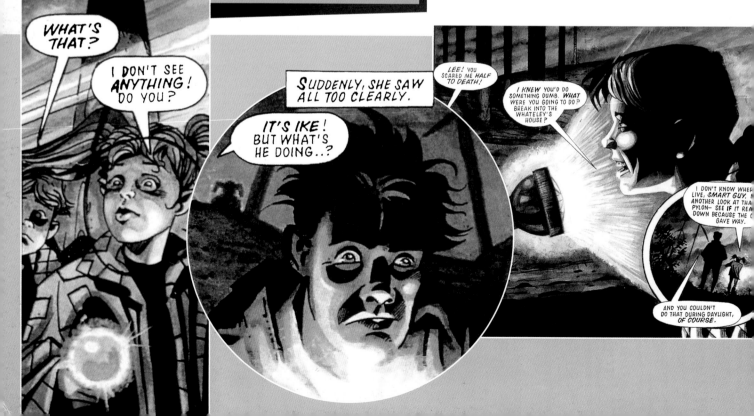

SHADOW AND HIGHLIGHT

The direction and number of light sources you use can have a dramatic effect on your characters' features.

FROM THE NEAR SIDE

Produces a stark portrait, flattening some features.

FROM BELOW

Another sinister look because it's unnatural. Throws areas normally lit into shadow.

FROM ABOVE

This deepens the shadows under the eyes, giving a sinister appearance.

TWO LIGHT SOURCES

Gives the face a more sensitive look.

EDGE LIGHTING

When only the tips of features are lit.

FROM THE SIDE

Delineates the features and can be used to emphasize character.

▶ NATURE'S FLOOD LIGHTING

Lightning is a brilliant light source, even during the day. A bolt of lightning will always light from above, and for a moment, completely over-expose an area. Depending on position, the flash can either illuminate or throw sudden, brief shadow.

TORCH-LIT NIGHT SCENES

◀ The strange thing about flashlights is they only illuminate what they're aimed at—there's very little scatter. The person carrying the torch will be almost invisible; and if you have the light beam shone in your face, you won't see a thing. A night scene where all that's visible are a few flashlight beams instantly raises questions: what are they looking for? Is someone lost? And a face abruptly caught in the beam still conveys a great deal of shock value.

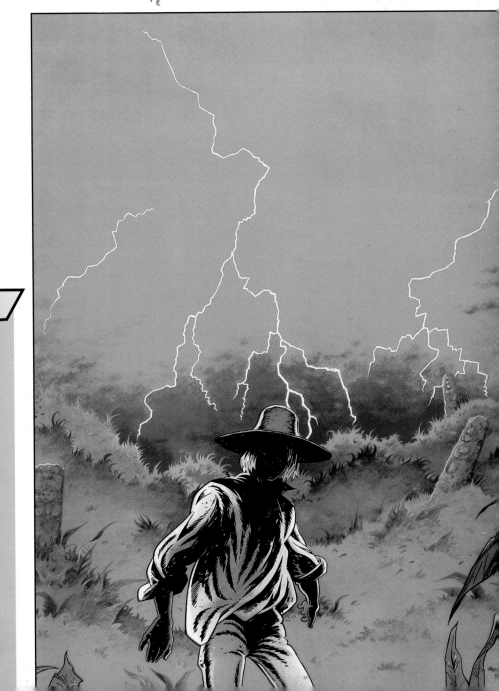

BODY LANGUAGE

Body language is something we've all inherited from our tribal, animal ancestors—simple visual signs that tell the rest of the pack how we're feeling, our status, and even what kind of mood we're in. They are visual clues that cut through all that tricky verbal language and its inherent ambiguity. Body language is rarely ambiguous—and generally, it's subconscious, too. With a bit of practice, you might be able to control some of your unconscious signals, but the action of the pupils and blood flow under the skin are way beyond the control of mere mortals.

The best use for body language in a graphic novel is to portray gestures that everyone understands. Posture is one of the most obvious—timid people shrink into themselves, while loud, aggressive types puff themselves up. People express interest and sympathy by leaning toward another person; disinterest is seen by someone pulling back. Crossing the arms is a defensive gesture, representing a shield that has been raised against the world. An even more obvious gesture is pointing at someone—this can convey a straightforward threat.

▶▶ SEE ALSO
Writing realistic characters, p.62

PROTECTIVENESS
This woman is cuddling a baby, holding him safe and close. Although her cheek resting against the baby, her eyes are watchful.

NERVOUSNESS
A young girl, sitting, wearing a short skirt. Her arms are rigid, her hands clasped together, and clamped between her thighs. She's obviously uneasy.

CONFIDENCE
Man sitting in a low chair. He's thrown back, arms resting along the chair's back. One leg is crossed carelessly over the other, ankle resting on knee.

CONCERN OR ATTRACTION
Two people, sitting together (different sexes). One is leaning toward the other, touching him or her lightly.

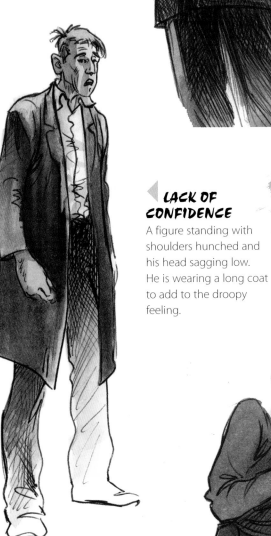

▶ STANDOFFISH

A figure standing, arms folded across his chest in a classic stance. To bring the point home, his head is slightly turned away, and the expression is stiff and indifferent.

▶ AGGRESSION

A man pointing, his whole arm rigid. It seems like he's aiming a weapon of some sort. His face is angry, too.

▼ DEFENSIVE

A figure huddled up, bent in on itself, arms wrapped around the vital parts of the torso.

◀ LACK OF CONFIDENCE

A figure standing with shoulders hunched and his head sagging low. He is wearing a long coat to add to the droopy feeling.

▼ AT EASE

Two people, standing. Their stances are almost identical—one is imitating the other, either to fit in or because he feels close.

▶ SHOCK OR FRIGHT

Hands thrown over eyes to protect vision, or simply to blot out whatever scared the figure.

LETTERING

Once you've penciled and inked your story (and colored it in, too), then comes the small detail of putting in the lettering. Publishing houses have staff specially employed to letter balloons and caption boxes—presumably because their calligraphy is clear and legible. Some publishers go one step further and actually print the text. If you're planning to do it yourself, the following are a few details that you need to be mindful of.

LETTERING FOR BEGINNERS

Here's a brief, step-by-step guide to creating letter balloons by hand using adhesive-backed paper.

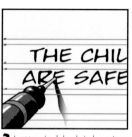

1 Lightly rule out guidelines in pencil

2 Letter in black ink, using a 0.5mm Rotring pen

3 Make sure the lettering is centered and symmetrical

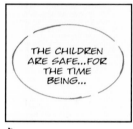

4 Sketch the balloon shape around the lettering

5 Cut the balloon out—make it as symmetrical as possible

6 Peel off the backing paper

7 Carefully put the balloon in place, then give it a black border with your pen

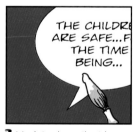

8 Mark in the tail with process white

The finished ball should look very professional

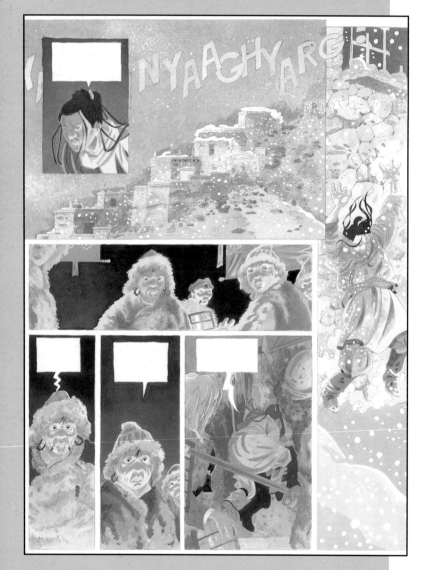

▲ DUMMY BALLOONS

To ensure you've left space in the artwork for all balloons and captions, you should try to include dummy balloons in early sketches of the pages. Then you'll have some idea of where to position characters and anything else that needs to be visible.

COMPUTER-GENERATED LETTERING

The typography you choose can indicate stress and volume, and even accents and language—but remember, it plays a major part in layout, too.

Imitating handwriting and typewritten scripts are just two examples of typography in layout. Handwriting is, of course, usually represented by cursive script—but done carefully, so that it's actually legible. Today, you can easily represent this with word-processing, of course, and graphics packages will allow you to drop lettering in anywhere you like—for example, italic fonts. But doing it by hand is better—less sterile—if you've the time and patience (and are skilled at calligraphy!). The three examples shown on the right in the balloons are all computer generated.

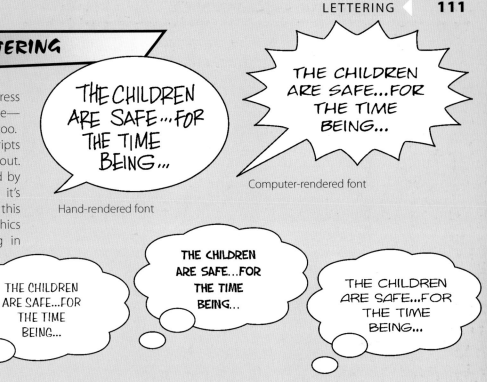

Hand-rendered font

Computer-rendered font

FONT PROGRAMS

Other than buying fonts, or downloading them, you can create your own using vector programs. These use lines rather than dots (like bitmap images) and are actually drawing programs. You can then use a desktop package to assemble your artwork and lettering.

▶▶ Illustrator is a Vector software from Adobe that will be familiar to anyone who has used Photoshop. Using a pen tool, you can create curves or lines by joining up points along the line or curve.

▶▶ QuarkXpress is a desktop design package. You can design your entire page by adding lettering and balloons (created elsewhere) and placing them over scanned artwork. It's no less difficult than doing it manually—but you can at least step back and do it again if you make a mistake.

▶▶ With Fontographer, you can not only import and edit existing fonts, but also create your own. But that's not your best option—creating a decent font that works properly isn't easy, and it takes a long time.

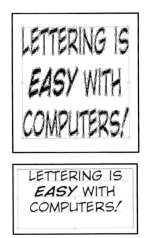

TOOLS

Left and above, fonts are re-sized using grids that show each individual letter's characteristics. Below, this detail from Fontographer shows the palette from which you select letters, color choices, and some of the tools available (bottom left).

▶▶ SEE ALSO
Speech and captions, p.28

SFX

Even if you don't read graphic novels, you will recognize the typical printed sound effects (or SFX, as they are known). All that "Biff" and "Splat" and "Ker-Plowy" got such a saturation airing on the old *Batman* TV show that it's not surprising that the use of SFX is much more subtle than it used to be.

For a while, when Marvel was in its ascendancy, the use of SFX became an art form in itself. It was all part of the fun. But graphic novels were originally meant to be more adult in tone than the average comic book, and that meant fewer silly noises.

But that doesn't mean you have to ditch them entirely. If there's something going on in a room nearby to where your characters are (gunshots, for instance), the only way the reader knows what's going on is through the reaction of your characters, and possibly one saying something helpful, like "Gunshots!" But you can dispense with cheesy dialogue by using a couple of well-placed "Blams!", along with character reactions.

No superhero strip can ever totally be without SFX. If you read through any superhero title today, you'll find the effects are still in there, but a little more discreet than they once were. They form part of the background, fitting in with whatever explosion, shot, or electric shock they're emphasizing. In fact, they've almost become subliminal. The reader absorbs them and acknowledges their impact, but barely even notices they're there.

AND THEN A TREMENDOU
THREW KURDIS OFF, SEN
SPRAWLING ONTO THE FL

▲ **TRANSPARENT**

Here, the typography expands outward, to follow the eruption. It's also done in outline, so as not to obscure the fiery blast.

▲ **AT THE CI**

The typography h
simple, but done i
to suggest brightr
placed at the cent
explosion. It almos
suggests that the
source.

INCORPORATING SFX

Color is a very important part of creating a m (dramatic reds and yellows can set alarm bells ringi our heads), and if you fill in the outlines and sti shadow to make the lettering appear to be coming from the page, it's even more dramatic. Even then typography chosen should not be random. Sharp so can be depicted with jagged, broken lettering, electric shocks with crackly, lightning bolt-style le Huge explosions should have the lettering radiating from the epicenter, following the angle of the Rocket blasts or ray beams have the sound ef shooting along their length—often angled forwar depict speed.

If you're drawing in your own effects, think how want to present them—either subtly (as seems to b current fashion), or in your face, retro style. If you g the latter, remember what has already been said a panels that look far too busy. You want the rea looking at your artwork and story, not being s shocked by the noises.

▲ **COMPRESSED**

This one is transparent like the example at above right, but the letters here are squeezed tightly together, even as the wording expands. It suggests a sudden, brief, loud noise.

MAJESTY — GET BACK!

TWANG!

SIMPLE

The typography is enclosed in an electric balloon to suggest a sharp, metallic sound.

ON THE EDGE

This is radiating out from the epicenter of the explosion, growing larger as the blast expands. The edges are slightly ragged, which gives the impression of damage.

BOOM!

KA-BOOM!

VOCALS

Jagged, uneven capitals give a feeling of a raw vocal sound.

ARRRRRGHHHHH HHHAAAARGH!!

SOLID

Here, the effect mimics the exploding debris, breaking up the words on impact.

KKRAK

OVER TO YOU

Think carefully about your use of sound effects. When they are overpowering, they can ruin the effect, but when they are too subtle, readers can miss them.

▶▶ *Draw a page that contains a series of action frames. It doesn't have to be chaotic, but it does need to contain movement. Doors and windows slamming, faucets dripping—that kind of thing.*
▶▶ *Make a few photocopies of the page and try out sound effects in various ways.*
▶▶ *Do one with large, unsubtle typography, and another with small, understated lettering.*
▶▶ *Mix up the two styles to suggest varying degrees of volume.*
▶▶ *Experiment with the typography itself— see how the wording can be shaped to suggest varying degrees of severity.*
▶▶ *Try and discover where to best place the lettering for maximum effect.*

GETTING PUBLISHED

So—you've written it, you've illustrated it, you've even colored and lettered it. Now what? Well, unless you're in this for the sheer joy of writing and drawing 100-plus pages of graphic novel, you'll want to try to sell it.

There are two ways to try to interest a publisher in your work: pitch and synopsis. They are quick ways of avoiding sending the whole book around to publishers.

PITCHING AT A PUBLISHER

A synopsis is the plot and story line, usually boiled down to around no more than 1000 words. You'll introduce your characters, outline their motivations, and describe how these characters interact. You'll also need to give the ending, explaining how everything works out. But the good thing about a synopsis is that no one expects you to stick rigidly to it once the story's been accepted and commissioned. If you feel that it works better by changing a few elements, then fine. But don't depart too far from the original concept.

You must remember that the synopsis is there to tell the editor exactly what your book is about. Tell him or her concisely and with enthusiasm. If you sound bored, don't expect an editor to get excited. Rambling on—cutting back and forth as though something's just occurred to you—is just as self-destructive. Writing a synopsis can be harder than writing the real thing, mainly because you have to include all the key elements and explain the story in such a short space, not making it sound like it's been written by someone with a vocabulary of 50 words who still can't manage coherent writing. Take your time, and put in as much effort as you would over the script—no sense rushing everything at this stage.

(a) Opening with description of atmosphere.

(b) The main character is introduced quickly.

(c) The next major plot detail is introduced right away.

(d) This tells the editor the story is told in flashback.

(e) Don't explain the whole plot—just supply a taste. Intrigue the editor.

SYNOPSIS LENGTH
Your synopsis should be no more than 1000 words.

THE PITCH
A pitch is up front and urgent. If a synopsis is the story boiled down, a pitch is just an idea you're trying to sell. See the Robert Altman movie *The Player* to discover what a pitch is.

Now, a graphic novel pitch has to be punchy. Not as long or as detailed as a synopsis, the pitch is intended to get the editor interested. It's the idea you're promoting, with a couple of scenes tossed in as examples. You don't need a complete storyline or list of characters (just the main ones). Chances are, if an editor is keen, he or she will want changes anyway.

The pitch obviously comes first. If you can interest an editor in your idea, then follow with the synopsis and sample script—script and sample artwork, if there's an artist on board already. The editor will want to read the synopsis for a fuller idea of the story, as well as look at the writing and artwork together to get an idea of how the book will look and sound.

Examples of a good way to pitch versus a bad way are explained below.

GOOD PITCH
(a) This story is set in the world of black operations. It will be atmospheric (think *X-Files*), but with a harsh, cynical edge (like *100 Bullets*). **(b)** A young man named Maldoon is kept prisoner in a government-run facility. He claims to be part of a group of heroic adventurers, but his story is inconsistent. **(c)** Yet, though a doctor constantly dismisses his claims, there are bodies—frozen in suspended animation—stored in the same facility. **(d)** Bodies, in fact, that closely resemble the members of the group he describes in deliberately comic book-style flashbacks. **(e)** It comes down to a simple question: who is everyone? Nothing is as it seems. Everyone, in some form or another, is lying. Why?

BAD PITCH
(a) Government agents are keeping Maldoon prisoner. **(b)** There are bodies frozen in suspended animation on the site. Maldoon believes he is a member of a group of superheroes, but the agents don't believe him. They claim he is delusional. **(c)** Maldoon recounts his adventures for the doctor, but everything the doctor tells them is dismissed and explained away. The frozen bodies look like the characters in Maldoon's stories.

(a) This rushes straight in. The first question that leaps into your mind is: who's Maldoon?

(b) The mention of the frozen bodies is out of place—it seems irrelevant.

(c) The whole pitch feels rushed and childish, with relevant plot points poorly explained.

SAMPLE SYNOPSIS

Here is a typical synopsis, the story we've been trying to pitch. The best way to present it is double-spaced, on one side of the paper, with an adequate margin all around. Make sure you have the title, along with your name, clearly marked at the top. Most synopses will be more than one page—so have page numbers, name, and title in the top right hand corner on all sheets.

This story is set in the world of black operations. It will be atmospheric (think *X-Files*), but with a harsh, cynical edge (like *100 Bullets*).

Mentioning that the doctor occasionally glances at the two-way mirror helps convey mood and atmosphere, which you want even for a synopsis.

occasional piece of ted speech can help ed up the synopsis, as as show the missioning editor well you handle gue.

You're indicating the story will be told largely in flashback —and in a retro style—and also highlighting some of the inconsistencies that are integral to the story.

SYNOPSIS: VIRTUALLY UNBREAKABLE

Mike Chinn

1 VIRTUALLY UNBREAKABLE: Mike Chinn

A dark office; a scene reminiscent of many a psychiatrist's consulting room. It is almost black and white: deep shadows thrown by stark desk lighting; the doctor/interrogator in a black suit and tie, white shirt, the other in dark coveralls. The 'patient' is always in partial shadow, so his face is never clear (except at the end, when he turns out to be in his sixties, not the young character of the flashbacks at all). There's a long mirror across one wall—typical of the 2-way style we're used to seeing in movies and on TV. The 'doctor' often glances at it surreptitiously.

The 'patient' calls himself Maldoon—a young agent with a Black Ops group. The doctor/interrogator is scathing, cynical. The atmosphere of the whole story is a cross between the TV series 'The Prisoner' and 'The X-Files': the overall paranoia of the first, with the darkness and ambivalence of the second.

Using flashbacks to examples of the Maldoon's 'adventures' (which are in gaudy prime colors – almost surreal), the interviewer gradually grinds away at his delusion. How is the interviewer expected to believe that four men can walk away from a plane crash, unhurt in any way—even down to a wristwatch? Why does Maldoon persist in claiming his fellow agents have such ludicrous names (Rex 'Red' Strong, Ace Merrill, Tiff Clayburn—or is that Clayburne?); is her name June Salieri or June Saunders? Why can't he even be consistent in the obligatory female character: is she blonde or black-haired; is her name June Salieri or June Saunders?

And why—since Maldoon wasn't even in the crash to start with—is he suddenly a member when his 'brother' goes missing.

"Isn't it all a typical grandiose delusion?" the interviewer insists. "First you're Jon Maldoon, the successful pop singer. But that isn't enough. You have to become second in command of a group of super agents. How come, since you're so famous, I've never heard of you? Or my kids? How can you insist—in the 21st century—that you're a major rock star when all you can perform is the kind of bland crap no one's heard since The Monkees!" Maldoon cannot answer any of these questions, and becomes increasingly agitated.

And all the while, there are frequent cuts to several people who seem to be looking through the mirror (later it turns out they are in Plexiglas 'coffins', and are simply gazing blindly through). All look identical to Jon Maldoon's friends—with two women, one blonde, one black-haired—but all are many years older than the ones from the 'adventures'.

Whilst Maldoon is sedated after he becomes especially agitated, the interviewer goes to who's really behind the 2-way mirror: someone very like Maldoon's idea of 'Ace Merrill'. The interviewer, referred to as Doc by 'Ace'—expresses concern for Maldoon's health. "I can't shake him, the concept's too deep..."

"Strong didn't show too much concern, Doc" 'Ace' replies. "Screwing his own kid brother over..."

'Red' Strong—was that an ironic title in the end!" Back in the 1960s, Strong had been part of a project not unlike the CIA's MK Ultra mind control experiment—before he defected and took all he knew to the Soviets.

"It's the consistency that gets me," Doc says. "All of them: the same story ... stories. Almost like they're really sharing them!" He returns to the interrogation room. On his way he passes a stark room—more mausoleum than lab. Inside are the 'coffins' containing the bodies of the aging agents.

The story ends ambiguously. Where is the reality? The darkened interrogation room? The agent's strangely interlinked dreams. Or even—as 'Ace' wonders—is one of the people in the 'coffins' dreaming even this...?

Once you've sent off your pitch, what can you expect? Let's not try to be too unrealistic—the chances are, first time, you'll get an outright rejection. That's not certain, of course. If you hit the market with an idea whose time has come, you'll make it overnight. But most overnight successes take years; you don't think Neil Gaiman's *Sandman* sprang fully-formed into the world, do you? Neil worked his apprenticeship just like anyone else, writing short fiction, getting to know people, polishing his craft. In fact, Neil is quite an unusual genre writer in that he's conquered both the graphic and conventional novel fields.

TAKING REJECTION
Don't ever ask for a detailed criticism of your work if it's rejected. Editors don't have that kind of time.

But, if your life follows a less exalted path, you'll probably end up hawking your story to many publishers before one picks it up. If you're lucky, some may tell you why it is being rejected.

If the pitch sparks interest, you'll be asked for a synopsis and sample pages. If you've got artwork, submit copies that illustrate the sample script pages for comparison. The editor will want to see how well both artist and writer perform (how well the writer writes and how the artist interprets the words).

PORTFOLIOS
Portfolios are what artists thrust under commissioning editors' noses and say "this is what I do." It's a catalogue of a body of work that editors can look at to see what the artist has done, is capable of, and how his or her style has changed and matured over the years. Writers have a harder job, as all they can do is hand over a bibliography or a few copies of comics they've scripted. If they're lucky, the editor will be familiar with the issues in question, and ask "so, you're the guy who wrote those?" Otherwise, the editor has to read through the copies, and in today's busy world, might not have the time.

Start your portfolio with your first sale: copies of both the original artwork and the finished comic book. If you want to keep copies of the books on your vanity shelf too, that's okay, but any copies you carry around are going to get worn. Stuff on the vanity shelf should be pristine—it's for gloating over, not reading.

Include material you haven't sold, too—as long as it's good stuff. Your portfolio is there to create an impression, so make sure it's a good one. Studies that you've done, landscapes—show the editor you've got range.

▶ COVER LETTER
Here's a good example of a cover letter to send with a submission. It's succinct, it reminds the editor you've met—and when—and offers him/her the chance to see what else you have done. Not all editors want a checklist of your successes; let the synopsis and samples speak for themselves.

SUBMITTING YOUR SCRIPT

The next question is—how do you submit the work?

▶▶ **DON'T** just turn up at a publisher and expect to be let in. Editors are busy and see no one without an appointment.

▶▶ **DO** double-space the lines, with a margin of at least one inch around the sides, top, and bottom.

▶▶ **DON'T** write back and tell whoever rejected your manuscript that he or she is wrong.

▶▶ **DO** put your name and the work's title (in abbreviated form if it's a little on the long side) in the top right hand corner, along with the page number.

▶▶ **DON'T** staple the pages! Editors don't get paid much and they live off the resale of paperclips—and they also like to separate pages.

▶▶ **DON'T** send original artwork. Not only is it expensive to mail artboard, but you don't want to risk losing anything.

▶▶ **DON'T** e-mail either script or artwork. Many editors are happy to receive e-mailed submissions—but check with them in advance to make sure it's okay.

▶▶ **DON'T** worry if you hear nothing for some time.

4546 Chapel H
Providence Valle
CA 99012
Tel: 415-555-4768

June 20, 2004

Francesca Grace
Commissioning Editor, Graphic Novels
Northeast Comics
1198 Lexington Avenue
New York, NY 102345

Dear Ms Grace,

It was a pleasure meeting you at the West Coast Comicon last month and I thank you for the interest you showed in my work.

Enclosed is a synopsis of a graphic novel—Execution—along with the script for seven sample comics pages with sample artwork attached. If you are interested in any other examples of my published work, my web site is at <www.cdward.com>.

I enclose an addressed envelope with adequate postage for your reply. The manuscript is disposable.

I look forward to your reply.

Yours sincerely,

Charles D Ward.

Charles D. Ward

▶ RING-BINDER PORTFOLIO

If you use a ring-binder portfolio, samples can be removed for passing around at meetings.

ORGANIZING AN EXCITING PORTFOLIO

A portfolio of your work as it grows and improves is essential. You can organize it by subject matter or chronologically (to show how you've improved!). It's up to you. The main point is that you can show examples of your work in a tidy and professional manner.

▶▶ Don't use too large a folder. Remember, you have to carry it, and editors don't want something the size of a table dropped on their desks.

▶▶ If the originals are large, get good quality copies made: photocopies or scanned-in prints.

▶▶ Use separate, detachable wallets for each piece of work. These can be handed around easily, while being protected.

▶▶ Only show material you're happy with. If you include work that you're not sure about the editor will pick up on it. You're there to sell yourself.

PROMOTIONAL MATERIAL

There are several ways that artists can present themselves and be remembered by commissioning editors.

▶▶ *Postcards with an example of your work on one side, and your contact details on the other.*

▶▶ *Your own personal logo on letters, business cards, invoices, compliments slips, postcards, and fliers.*

▶▶ *Fliers. One-page ads.*

▶▶ *Web sites and e-mail. A web site can contain a gallery of your work, reproduced perfectly and almost cost-free.*

SUBMITTING YOUR ARTWORK

Whatever job you're working on, always approach it professionally. Finished art should be submitted in the correct size, mounted, protected, and clean. It stands to reason that clean artwork will reproduce better. Furthermore, if you've protected it properly, you'll get it back clean, too.

▶▶ *DO present each page on a separate board or strong paper that you've mounted on board (but only at the corners).*

▶▶ *DON'T leave too much white space at the edges. Excess white will simply be trimmed off during reproduction. Because boards are expensive, not using as much as you can is wasteful.*

▶▶ *DO cover each board or sheet with clear layout or visualizing paper. This not only protects both art and paper, but provides space for any special proofing requirements or sizing notes (either yours or your publisher's) to be written.*

▶▶ *DON'T USE different sized boards—a carefully packed, uniform-sized package stands the best chance of surviving both the mail and publishers.*

▶▶ *DO write the title of the book and publisher on each board—in case the protection sheet gets lost. Also, add the page number (book page, not manuscript) and your name.*

PROTECTING YOUR ARTWORK

If your work's not on artboard, you should mount it on board to protect it in transit, and show you care about your work. If you treat your work with respect, then others will too.

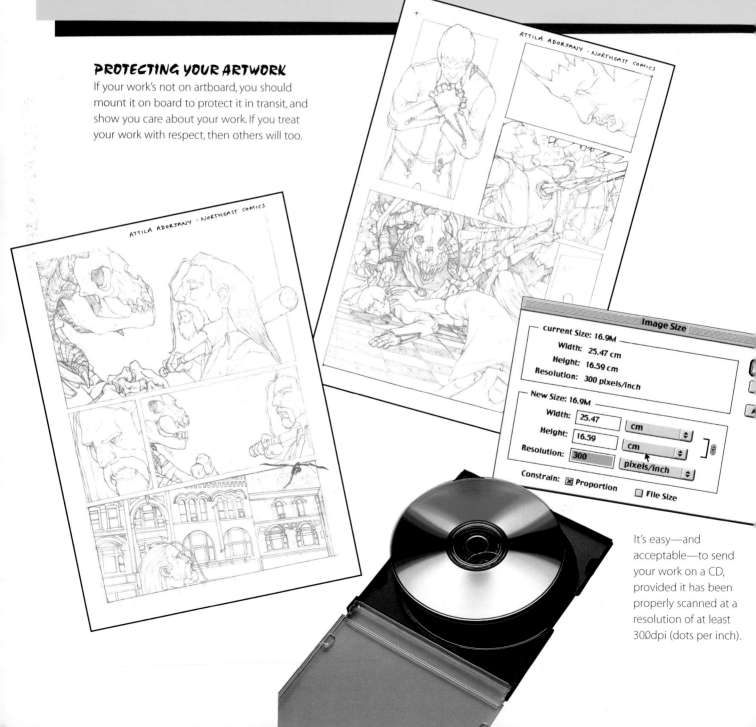

It's easy—and acceptable—to send your work on a CD, provided it has been properly scanned at a resolution of at least 300dpi (dots per inch).

CONTRACTS AND AGENTS

And now a word about negotiating your contract: be careful. In other areas of art and writing, the creators hire themselves an agent and let him or her do all the work. But in the comics' field, it's rare. That's not to say there aren't agents for the field—if you look in the resources section at the back of the book, you'll find a web site dedicated purely to comic-book agents

So the alternative is to get a book detailing an author's and artist's rights. Something like *Artist's Market* or *Writer's Market*. Both have sections on rights, copyright, and intellectual property —as well as lists of publishers and societies throughout the world. Or, if you want more detail, seek out a specialist title, such as *The Rights of Authors, Artists and Other Creative People* (Norwick and Chasen) or *The Internet and Authors' Rights* (Pollaud-Dalian, ed.).

And, finally, there are artists' collectives whose aim is to look out for the rights of comic book creators. They can easily be found on the Web.

COPYRIGHT

Now we're approaching the sticky stuff—rights. Copyright. Who owns what, and for how long.

Copyright is something with which you're going to have to get acquainted. All published work is copyrighted—the very act of publishing is recognized as registering copyright for that particular work. It's even possible to have an unpublished work copyrighted—but we don't want to get into that here. The purpose of copyright is to prevent plagiarism—the theft of your work by someone who presents it as his or her own. Full-time writers and artists don't want to spend months over something just to have it stolen from under their noses. Sadly, all the copyright laws in existence still don't prevent it from happening. European publishers are notorious for translating and reprinting books illegally, the creators blissfully unaware—until some accident reveals all.

Copyright exists on a work for the duration of the creator's life plus a specified term after death. In the U.S. and the European Union, that presently stands at life plus 70 years.

You'll often see the term "intellectual property"—this is the law covering copyright as well as patents and trademarks. To all intents and purposes, "intellectual property" can be considered your book, script, or whatever, and the Intellectual Property Law stands as Copyright Law.

When you make a sale, the ideal situation is you just sell first U.S. publication rights, or first foreign publication rights. This means that the company's buying, from you, the right to publish—just once—your book.

Your contract will determine how long the publisher retains the rights to your work (it could be for life, or it could be

when the book goes out of print). It also covers whether you will receive a flat fee or advance against future royalties. Royalties are an agreed percentage that you will receive from the book's sales, but the book has to earn back your advance first.

But often you'll find publishers buy all rights. And this is just what it sounds like. Once you've signed on the dotted line, the book belongs to the publisher. The story and all characters contained within are now the intellectual property of the publisher. You get no royalties; any movie sales go to the publisher. You may get the chance to write further adventures of your hero, except he won't be your hero any longer. Also, the publishers might want to develop him in ways you hate.

GET YOUR ART BACK

Always ask the publisher for your original artwork to be returned. Unless specifically stated in the contract, the publisher does not own it. Once you have it back, you can sell it yourself; often from your web site.

THE INTERNET

The world's largest publishing market, in a sense, and you can pretty well include just about anything you want. The Internet's greatest strength is the way it gets around censorship, and its greatest weakness is the way it gets around censorship. Publishing anything electronically has similar pros and cons.

SERIALIZATION

There are scores of comic strips and cartoons on the Internet, but, to the best of my knowledge, there haven't been any e-graphic novels yet. And there's a very simple reason for this: space. Or size, if you will. Internet servers always give you a certain amount of free space for your own web site—ten megabytes seems about average—but using a lot of graphics is one certain way of filling that space in no time. Good quality graphics files are large, and often take a while to download, depending on bandwidth.

So what do you do? Serialize, is the obvious answer. Most cartoons and strips on the Internet are changed on a regular basis; running your graphic novel as a serial would be perfect, especially if you can end each episode with a cliff-hanger.

E-MAGAZINES

You don't need to go it alone, either. Creating your own web site and maintaining it is time consuming—time you could put to better use writing or drawing a new book. There are a variety of e-magazines out there publishing everything from news and reviews to prose fiction and comic strips. Search them out, and see which ones are the likeliest bet to publish your stuff. All you have to do is provide fresh material for each new deadline—they'll do the complicated and timely bits.

GOING IT ALONE

But if you do want to do everything yourself, preparing a page of artwork for electronic publication is easy enough. You'll need an index page to begin with—something to explain who you are, what the book's about—and the story so far. The simplest way to create that is to use a word processing package like Microsoft Word—laying the text out as you want, choosing background and text colors—and saving it as an HTML file when you're done. You may need to go back and forth between the original file and HTML file because HTML documents alter the size and layout of

the original page, and you might find sections mov[ing] around in an odd way. To enter the latest episode of yo[ur] book, you'll need to insert a link—best from a thumbn[ail] of a piece of artwork—and, with a mouse click, select a[n item] to link to that item. All files that you want to publish [to] the Internet should be in the same separate folder; [it's] easier for you and the computer to find. The file in t[his] case is your artwork, scanned in and saved appropriat[ely] (remember, large files take time to download; it's [a] compromise between quality and speed).

WEB PUBLISHING SOFTWARE

Once you're done, you can publish! For newcom[ers,] Microsoft's Web Publishing Wizard is recommended—[it] walks you through the stages and sets everything up [for] you. But once you've become more proficient (a[nd] confident), use a piece of FTP software. You can look [at] both the folder on your computer and the one on yo[ur] ISP at the same time, selecting which items you want [to] transfer and (remembering, you have only so mu[ch]

YOUR WEB SITE

A carefully maintained w[eb] site is as much an adver[t for] you as your work. A professional-looking we[b] site suggests someone [with] a professional attitude.

space) which to delete. Microsoft's Publishing Wizard will only allow you to transfer onto the Internet.

COPYRIGHT

The biggest problem with anything available on the Internet is enforcing copyright. Intellectual Property Law already covers anything you're likely to publish, and new laws are being enacted all the time to further tighten up breaches of copyright. But the truth is, on the whole, it's practically impossible to prevent someone doing whatever he or she wants with data downloaded into his or her computer. Once your book is on the Internet, there's very little you can do to prevent anyone copying it and using it in an unauthorized way.

TERMINOLOGY

Don't be afraid of the acronyms used in computing and on the Internet—their bark's worse than their byte…

FTP—This stands for File Transfer Protocol, a facility on the Internet that allows you to copy files from one computer to another. The address (or URL) is usually something like ftp://ftp.somewhere.com.

HTML—Hypertext Markup Language is a method of marking up (or tagging) a document so that it may be published on the Internet. A typical URL would be http://www.apage.com.

URL—Uniform Resource Locator, an address for a web site.

*JPEG—Joint Photographic Experts Group. A graphics format best used for photographs. The usual file extension is *.jpg.*

*GIF—Graphics Interchange Format. A graphics format that is best used for line art, logos, etc. Because it's limited to 256 colors, it's not too good for photographs. File extension *.gif.*

SIZE DOES MATTER

Some of the graphics formats mentioned above have varying degrees of compression (how small they can be squeezed without losing too much resolution). On the Internet, size and speed are connected—the larger something is, the longer it takes to download.

▶▶ JPEGs are the most compressed form of graphics. Consequently a JPEG will download quickly—but it has limitations. Although this format supports almost unlimited colors, it doesn't support one of the two color formats, CMYK, which we'll come to in a moment.

▶▶ GIFs are slightly larger files and, as we've mentioned earlier, only support 256 colors.

▶▶ TIFFs are another popular graphics filter. Tagged Image File Format supports up to full color RGB and CMYK images. However, TIFFs are usually massive files due to all the information stored in them. File extension *.tif.

▶▶ Windows Bitmap is another popular filter. But, like TIFFs, bitmaps can use up a lot of memory. Normally the file extension is *.bmp.

It's important to note that, if you're using Word to create your HTML document, when you insert a JPEG it stays as a JPEG, but bitmaps and TIFFs will be converted to GIFs.

RGB—literally Red, Green, Blue. These are the transmitted primary colors—or what you see on your computer screen. Mixing them variously gives the CMYK colors (see below). All three together make white; the absence of all three makes black.

CMYK—or Cyan, Magenta, Yellow, and Black. These are the primary colors used in printing, therefore, they are reflected light. The opposite of RGB, mixing them should, in theory, create black (it doesn't), while their absence creates white (or the color of the paper). Because B has already been used for blue, Y is substituted; and because mixing cyan, magenta, and yellow gives you muddy brown, printers actually use black toner as well.

OVER TO YOU

▶▶ *Experiment with various graphics filters. Save an image in the various formats and compare file size.*

▶▶ *Take a particularly vivid image and change it between RGB and CMYK color formats. Compare the two. Is there any obvious difference on screen?*

▶▶ *Create a dummy web page and save it as an HTML (if you haven't got any of the specific programs to do this, you can save a Word document in HTML format). View it as an HTML page. Has the positioning of the text and images changed from the layout in Word?*

RESOURCES

GENERAL WORKS ON GRAPHIC NOVELS

- ▶▶ Caputo, Tony C., *How To Self-Publish Your Own Comic Book*, Watson-Guptill, 1999

- ▶▶ Clarke, Phil and Higgs, Mike, *Nostalgia About Comics*, Pegasus, 1991

- ▶▶ Eisner, Will, *Comics and Sequential Art*, Poorhouse Press, 1985

- ▶▶ Gertler, Nat (ed.), *Panel One: Comic Book Scripts by Top Writers About Comics* (first in a series), 2002

- ▶▶ Goulart, Ron, *Comic Book Culture: An Illustrated History*, Collectors Press, 2000

- ▶▶ Harvey, Robert C., *The Art of the Comic Book: An Aesthetic History*, University Press of Mississippi, 1996

- ▶▶ McCloud, Scott, *Reinventing Comics*, Paradox Press/D. C. Comics, 2000

- ▶▶ McCloud, Scott, *Understanding Comics: The Invisible Art*, Kitchen Sink Press, 1993

- ▶▶ Naepel, Oliver, *Auschwitz im Comic—Die Abbildung unvorstellbarer Zeitgeschichte [Auschwitz in Comics—The Depiction of Unimaginable Contemporary History]*, Muenster: LIT, 1998

- ▶▶ Perry, George and Aldridge, Alan, *The Penguin Book of Comics*, Penguin, 1971

- ▶▶ Rothschild, D. Aviva, *Graphic Novels, A Bibliographic Guide To Book Length Comics*, Libraries Unlimited, 1995

- ▶▶ Sabin, Roger, *Adult Comics: An Introduction*, Routledge, 1993

- ▶▶ Sabin, Roger, *Comics, Comix and Graphic Novels: A History of Comic Art*, Phaidon, 1996

- ▶▶ Salisbury, Mark, *Writers On Comics Scriptwriting*, Titan Books, 1999

- ▶▶ Skinn, Dez, *Comix: The Underground Revolution*, Thunder Mouth's Press, 2004

- ▶▶ Varnum, Robert (ed.), *The Language of Comics: Words and Image*, University Press of Mississippi, 2002

- ▶▶ Weiner, Stephen, *101 Best Graphic Novels*, NBM Publishing Inc., 2003

- ▶▶ Weiner, Steve (et al), *The Rise of the Graphic Novel: Faster Than a Speeding Bullet*, NBM Publishing, 2003

BOOKS ON WRITING AND DRAWING TECHNIQUES

- ▶▶ Chelsea, David, *Perspective! For Comic Book Artists*, Watson-Guptill, 1997

- ▶▶ Chiarello, Mark and Klein, Todd, *The DC Guide to Coloring and Lettering Comics*, Watson-Guptill, 2004

- ▶▶ Eisner, Will, *Graphic Storytelling and Visual Narrative*, Poorhouse Press, 1996

- ▶▶ Hart, Christopher, *Drawing Cutting Edge Comics*, Watson-Guptill, 2001

- ▶▶ Hart, Christopher, *Manga Mania: How to Draw Japanese Comics*, Watson-Guptill, 2000

- ▶▶ Hogarth, Burne, *Drawing Dynamic Hands*, Watson-Guptill, 1988

- ▶▶ Hogarth, Burne, *Drawing Dynamic Light and Shade*, Watson-Guptill, 1991

- ▶▶ Hogarth, Burne, *Drawing Dynamic Wrinkles and Drapery*, Watson-Guptill, 1995

- ▶▶ Hogarth, Burne, *Dynamic Figure Drawing*, Watson-Guptill, 1996

- ▶▶ Janson, Klaus, *The DC Comics Guide to Penciling Comics*, Watson-Guptill, 2002

- ▶▶ Janson, Klaus and Miller, Frank, *The DC Guide to Inking Comics*, Watson-Guptill, 2003

- ▶▶ Lee, Stan and Buscema, John, *How to Draw Comics the Marvel Way*, Fireside, 1984

- ▶▶ Martin, Gary, *The Art of Comic Book Inking*, Dark Horse Comics, 2002

- ▶▶ McKenzie, Alan, *How to Draw and Sell Comic Strips for Newspapers and Comic Books*, North Light Books, revised 1998

- ▶▶ O'Neill, Dennis, *The DC Comics Guide to Writing Comics*, Watson-Guptill, 2001

- ▶▶ Smith, Andy, *Drawing Dynamic Comics*, Watson-Guptill, 200

- ▶▶ Stradley, Randy, *The Art of Comic Book Writing*, Dark Horse Comics, 2002

- ▶▶ Williamson, J. N. (ed.), *How to Write Tales of Horror, Fantasy, and Science Fiction*, Writers Digest Books, 1987

ᴹAGAZINES AND ᴾERIODICALS

Comics International, Quality Communications Ltd., 345 Ditchling Road, Brighton, BN1 6JJ, UK. News, reviews, and comprehensive listing of worldwide comics publishers

The Comics Interpreter, comicsinterpreter@hotmail.com, The Abscess Press, Reviews, in-depth articles, and interviews with comic creators

The Comics Journal, Fantagraphics Books, 7563 Lake City Way NE, Seattle, WA 98115, USA. Industry news, professional interviews, and reviews

ᴼRGANIZATIONS

Comics Creators Guild (formerly Society of Strip Illustrators), 22 St. James' Mansions, West End Lane, London, NW6 2AA, UK

Graphic Artists Guild, 90 John Street, Suite 403, New York, NY 10038, USA

ᵂEB SITES FOR AND ABOUT GRAPHIC NOVELS

www.ala.org/ala/yalsa/teenreading/trw/trw2002/resources.htm
old site, but contains good list of recommended research materials

www.artbomb.net/comics/introgn.jsp
page comic *What is a graphic novel?* drawn by Jessica Abel

www.comicsresearch.org
book length works about comic books from histories written by enthusiasts to academic monographs

www.crossgen.com
official web site of CrossGen Comics

www.darkhorse.com
official web site of Dark Horse Comics

www.dccomics.com
official web site of D. C. Comics

www.diamondcomics.com
of Diamond Comics distributors—reviews and direct sales

http://dmoz.org/Arts/Comics/Reviews
directory—links to articles and other research facilities

http://freud.franklin.edu/mcgurr01/GNW%20files/GNWresources.htm
Graphic Novel Resource warehouse with links to a variety of graphic novel sites

www.koyagi.com/Libguide.html
Library site dedicated to Manga

www.library.yale.edu/humanities/media/comics.html
Yale University Library site—huge resource catalogue

www.marvelcomics.com
Official web site of Marvel Comics

http://my.voyager.net/~sraiteri/graphicnovels.htm
Recommended graphic novels for libraries—comprehensive list of titles

www.noflyingnotights.com
Graphic novel reviews site for teens

www.rationalmagic.com/Comics/Comics.html
On-line reviews and interviews; recommended reading lists

www.tcj.com
The Comics Journal web site—see above

www.thefourthrail.com
Up-to-date reviews, forum site, with archives

www.tokyopop.com/books/manga.php
Comprehensive importer of Manga and Animé material

http://ublib.buffalo.edu/libraries/units/lml/comics/pages
Library site—recommended titles, publishers, genres, etc.

www.viz.com
Manga and Animé site—reviews and sales

www.writers.net/agents/topic/120/
Links to agents, publishers, etc. specific to graphic novel field

INDEX

CREDITS

Quarto would like to thank and acknowledge the artists listed below who kindly allowed us to reproduce examples of their illustrations and photographs. In addition, we are indebted to the following illustrators for their artwork, specially commissioned for this book: Jon Haward, Joel Orff, Quique Alcatena, Ron Tiner, Ruben de Vela, Katy Coope, Thomas Crielly, Steve Parkhouse.

(Key: l left, r right, c center, t top, b bottom, bg background)

1, 71t, 107b, 110l Gioux and Dellisse © Glénat
2t, 10t, 11, 15, 16, 18t, 24, 40r, 41, 56, 63, 67b, 70t, 74c, 74b, 75l, 106b Alan Burrows
2b, 13b, 21, 28tl, 28tr, 30, 49b, 53tr, 55b, 70r, 113bl, 113bc, 113br, 114br, 122 Michel Gagne www.gagneint.com
2–3bg, 31tl, 31tr, 66, 81tr, 106t Gary Spencer Millidge © 2004 Gary Spencer Millidge/Abiogenesis Press
3t, 20b, 24, 64l, 93b, 103l, 103c, 105b, 112t, 112b NEGATION—V.1, Issue #6. Tony Bedard, Andy Smith, Brad Vancata, Jason Lambert © CrossGen Intellectual Property, LLC 2000, 2001, 2002, and 2003. All rights reserved
3b, 13t Alan Moore and Eddie Campbell © Knockabout Comics. All rights reserved
4r, 23t, 26b, 49t, 72t, 102t, 105t THE FIRST—V.1, Issue #21. Barbara Kesel, Andy Smith, Brad Vancata, Jung Choi © CrossGen Intellectual Property, LLC 2000, 2001, 2002 and 2003. All rights reserved
5l, 29tl, 54b, 114bl, 119bl, 119br Alex Storer and Tony Bates/Fatdog Comics www.fatdog-comics.co.uk
5c, 20t, 96 Quique Alcatena
5r, 19, 23b, 40c, 52, 55t, 67t Joel Orff
6tl, 7tl Bettmann/CORBIS
6tr Stapleton Collection/CORBIS
6cl, 6bl Miller/Fawcett cpt/THE ART ARCHIVE
6cr, 6br (all 3) Amalgamated Press/THE ART ARCHIVE
7r Swim Ink/CORBIS
7bl Forrest J. Ackerman Collection/CORBIS
8t Annebicque Bernard/CORBIS
8bl, 32br, 38b 20th Century Fox/THE KOBAL COLLECTION
8br Cameron Denis/CORBIS SYGMA
10t, 114tl, 119tl Gioux and Cothias © Glénat
10r, 18b, 64r, 65c, 106cr Ken Meyer Jr. www.kenmeyerjr.com
10bl, 14 Jon Haward © Marval Characters Inc. All rights reserved
10br Gioux © Editions Encrage
12, 102b Bob Covington
17 Jon Haward © 2003 Games Workshop. All rights reserved
20c, 27tl, 27tr Jon Haward and Angus McKie
22, 46, 47, 62, 104 ECO SQUAD—Issue 3 + 4. Mark Iacampo, Kevin Phillips, Hal Lane © Grand Canyon Association. All rights reserved
26t Gioux © Glénat
27b, 28bl, 28br, 92 TALES OF TELGUUTH. Steve Moore, Jon Haward, Angus McKie © 2003 Rebellion A/S 2000AD PROG 1329. All rights reserved
29tr, 36t, 36br, 37tr, 40tl, 50, 51, 53br, 54t, 65b, 103r David Hine www.twoillustrators.com

29b, 53l, 115, 116 Daniel Harris O'Malley
32bl, 38t John Springer Collection/CORBIS
35t Royalty-Free/CORBIS
58t, 74tl, 74tr, 75t, 75r Matt Busch
58b, 82b, 83bl, 83br, 95tr Finlay Cowan
65t Christophe Vacher
68tl *New Scientist*
72b Abby Ryder www.abbysartpage.com
73t Katherine Coope (art), Lynne Triplett, and Katherine Coope (character)
81b, 121, 125 Katherine Coope
83tl, 83tr, 83c Nick Stone
86, 87, 88, 89t, 89c, 90, 91 Jon Haward © 2003 Rebellion A/S 2000AD. All rights reserved
89b Rodney Buchemi
112c STARBLAZER #250. Mike Chinn, Quique Alcatena © 1989 D.C. Thompson and Co. Ltd. All rights reserved
113t STARBLAZER #200. Mike Chinn, Quique Alcatena © 1987 D.C. Thompson and Co. Ltd. All rights reserved
114tr, 119tr Gioux and Duval © Delcourt
120l, 120t Attila Adorjany, for "Covenant of the Fallen Grace" written by Shaun Armour